STAFFORDSHIRE'S MILITARY HERITAGE

Adrian & Dawn L. Bridge

AMBERLEY

First published 2022

Amberley Publishing
The Hill, Stroud
Gloucestershire, GL5 4EP

www.amberley-books.com

Copyright © Adrian & Dawn L. Bridge, 2022

Logo source material courtesy of Gerry van Tonder

The right of Adrian & Dawn L. Bridge to be
identified as the Author of this work has been
asserted in accordance with the Copyrights, Designs
and Patents Act 1988.

ISBN 978 1 3981 1011 3 (print)
ISBN 978 1 3981 1012 0 (ebook)

British Library Cataloguing in Publication Data.
A catalogue record for this book is available from the
British Library.

Origination by Amberley Publishing.
Printed in Great Britain.

Contents

Introduction

During the course of this book, the rich and varied military heritage of the historic county of Staffordshire will be explored in some detail. The historic county was of a considerable size, covering some 1,250 square miles, and included areas such as Walsall, West Bromwich and Wolverhampton, which were lost to Staffordshire as a result of local government reorganisation in 1974 and subsequently became part of the new county of West Midlands. Similarly, the Stoke-on-Trent area formed its own independent unitary authority, separate from Staffordshire, in 1991. Nevertheless, Stoke was an integral part of the historic county of Staffordshire and therefore falls within the scope of this study. Landlocked, 'historic' Staffordshire, surrounded by the counties of Shropshire, Derbyshire, Cheshire, Leicestershire, Warwickshire and Worcestershire, was a land of great contrasts, from the extensive moorlands and rural market towns of the north-east to the industrialised areas of the south and south-east. Coal and iron ore were extracted from the Walsall area way back in the thirteenth century, Wolverhampton was an important staple town for wool during the fourteenth century, and pottery became important in Stoke from the early eighteenth century onwards. More recently, Staffordshire's extensive coalfield deposits were of vital importance in sustaining Britain during two world wars. Staffordshire's industrial importance made it a target for German bombing in both the First and Second World Wars, but the county was of military and strategic significance long before the advent of massive industrialisation.

Staffordshire's geographical position, in the central part of England, made it a key routeway for armies travelling in all directions across Britain. Thus, Roman legionaries marched through the area later to become Staffordshire in order to go to and from Wales and the northern parts of Britain, and later Yorkist, Lancastrian and Stuart armies followed many of the same routes. Staffordshire was therefore the scene of numerous military skirmishes, battles and sieges (from the Saxon period onwards), which together form an important part of the county's overall military heritage. Staffordshire's military heritage does, however, extend far beyond the confines of the county itself. Since the early 1700s, at least ten significant military formations (excluding various Volunteer units) have been based in Staffordshire and carried the Staffordshire name into battle in countries across the world. In addition, Staffordshire-based Royal Air Force (RAF) aeroplanes launched aerial offensives deep into the heart of

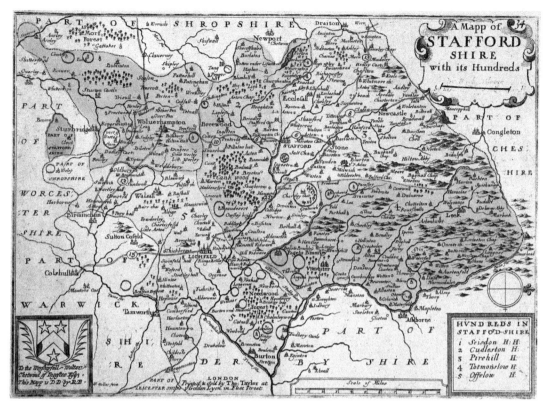

Wenceslaus Hollar's seventeenth-century map of Staffordshire. (© Thomas Fisher Rare Book Library)

occupied Europe during the Second World War. The legacies of Staffordshire's rich military heritage consequently reach across the world, from Commonwealth War Graves (CWGC) in Europe, Africa and the Far East to battlefield memorials, ruined castles and regimental museums in the county itself. All in all, it's an epic martial story, covering well over a thousand years of history, which should be a source of considerable pride to the people of Staffordshire. We hope you find the book both enjoyable and informative.

1. Military Beginnings

Within ten years or so of the Roman invasion of Britain, launched by the Emperor Claudius in CE 43, the legions were present in, and moving through, the area that later became known as Staffordshire. Evidence for the Roman military presence in the area is, however, quite limited. There were two Roman forts at Kinvaston, near modern Penkridge, which were the permanent bases for army auxiliary units, and a military base at Letocetum (situated in the modern parish of Wall, just to the south of Lichfield). The Gemina XIV legion spent a limited time at Letocetum during the mid-50s CE. Essentially, the Romans maintained a military presence in the area in order to guard vital road networks that led towards Wales and the northern parts of the province of Britannia. However, by the early fifth century CE, the Romans had left Britain for good, and during the subsequent 150 years a new wave of invaders – including Angles, Saxons and Jutes – had swept into Britain from the north German coast and pushed the native Celts back into the westernmost fringes of the British Isles. The Saxon invaders who advanced along the River Trent created settlements in the Staffordshire area, which eventually formed the core of the powerful Saxon kingdom of Mercia. Although Mercia is synonymous with the Midlands, at its height the kingdom encompassed territory stretching from Chester in the north-west to London in the south-east. For much of the period between the sixth century CE and the rise of Wessex in the late ninth century CE, Mercia was the dominant Saxon kingdom in the heptarchy of seven Saxon kingdoms that eventually made up a united England. Mercian dominance was promoted by warrior kings such as Offa who, in the mid-seventh century, often ruled from his favourite royal palace in the Staffordshire settlement of Tamworth. Ultimately, success or failure for Mercian rulers like Offa depended upon the prowess of their armies on the battlefield, and victory or defeat usually depended upon the strength of their shield wall. A Saxon shield wall in Mercia, and elsewhere, was composed of only the toughest and ablest warriors. These warriors would come together and overlap their shields in a tight formation that would then meet the enemy warriors head-on in a heaving and bloody close-quarters clash. In the spaces between shields opposing warriors would use their spears, swords and axes to hack at the exposed heads, arms, feet and torsos of their enemies. Behind the front row of the shield wall stood the more mobile, sometimes less-well-equipped second row, ready to fill in any gaps and replace casualties, and behind the second row stood the Saxon commander,

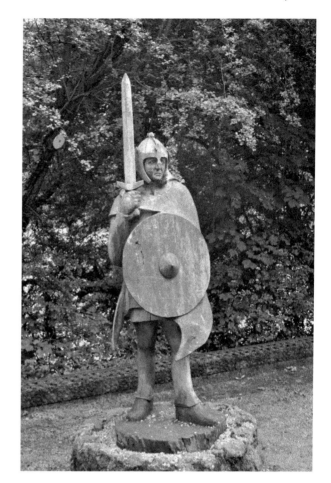

Right: King Offa of Mercia statue.
(Courtesy of Colin Cheeseman)

Below: Saxon shield wall from the
Bayeux Tapestry.

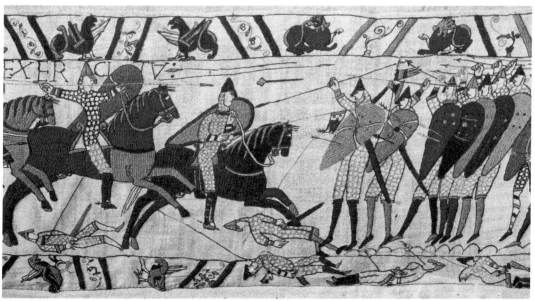

with the housecarls and thegns who made up the royal bodyguard. A Mercian Saxon army or host was also likely to be small, numbering in the hundreds rather than the thousands, and it operated as one amorphous mass without separate wings or divisions. Saxon armies in Mercia and elsewhere were almost entirely infantry forces. Horses were used to move forces about from one position to another, but once battle was joined the animals were moved to the rear.

Staffordshire was really a creation of the ninth century CE, and in the CE 870s Saxon Staffordshire, Mercia and the rest of Saxon England had to face the challenges posed by the invasion of the feared Norsemen from Denmark, Sweden and Norway. These Danish invaders – the Vikings of legend – had first raided the island of Lindisfarne in CE 793, but by the CE 870s the Danes were intending to settle on Saxon lands. Mercia was overrun by Danish raiders led by Halfdan in 874, and virtually the whole of England, bar Wessex, came under Danish control. The Saxon fightback against the Danes was led by Alfred the Great's West Saxons, and not by Mercia. Alfred's military victories against the Danish led to a temporary truce in which the Danes were allowed to settle to the east of what was called the Danelaw. This Danelaw partition split England into two, with parts of Mercia controlled by the Danes and other parts ruled by the Saxons. Staffordshire became a frontier area, theoretically part of the Saxon Mercian kingdom, but constantly raided by nearby Danish war bands.

Staffordshire's salvation, and that of Mercia, really came with the marriage of Alfred the Great's daughter, Aethelflaed, to Aethelred, the king of Saxon Mercia, in CE 885. Aethelflaed was really one of the greatest figures of England's so-called Dark Ages, and at the time she was revered almost as much as her father, the great Alfred. In CE 902, her husband, Aethelred, was incapacitated by illness and from this time onwards, in alliance with Wessex, she led Mercia in its struggles against the Danes. Aethelflaed was every inch the warrior queen; she would accompany her armies on campaign and had a good grasp of military, as well as political, strategy. In CE 909, Aethelflaed's Mercian army launched a five-week offensive, in alliance with Wessex, against the Danes of Lindsey (in modern Lincolnshire). In retaliation the Danes launched a substantial invasion of Staffordshire and Mercia during CE 910. Supplied by a fleet that sailed down the River Severn, the Danes ravaged the farms and settlements of Staffordshire, but were eventually cornered by the armies of Aethelflaed and Wessex during August CE 910 at Wednesfield, near Tettenhall. The Saxon and Danish armies, which clashed at Wednesfield, were basically very similar. Both recognised the supremacy of the shield wall, and the Danes (like the Saxons) were at heart an infantry force. The Battle of Wednesfield resulted in a great Saxon victory, in which the Danish shield wall was smashed and (at least according to the *Anglo-Saxon Chronicle*) thousands of Danes were killed. Danish casualty figures were undoubtedly exaggerated, but the Saxon victory was certainly a significant one, which marked the very last occasion when a raiding army from Denmark attempted to plunder the lands of England.

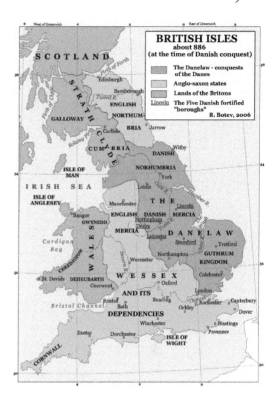

Mercia, Wessex and Danelaw.

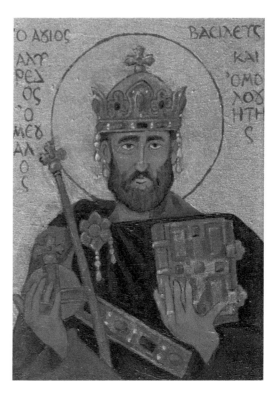

Byzantine-style icon of King Alfred.
(Father of Eitore)

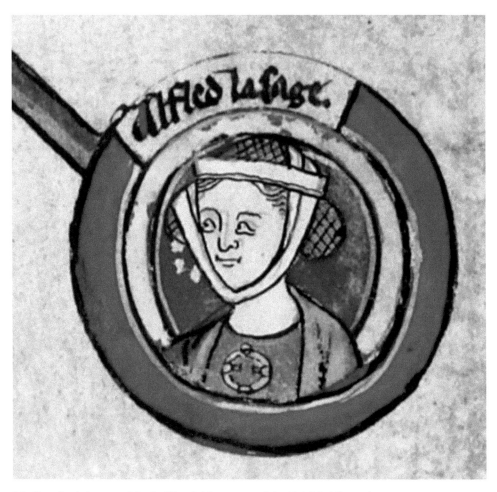

Medieval miniature of Aethelflaed. (Courtesy of the British Library)

Although the armies that clashed at Wednesfield were undoubtedly very similar, it was the differences in military strategy and technologies that ensured it was the Saxons rather than the Danes who were ultimately triumphant in Staffordshire and elsewhere. In particular, Aethelflaed pursued her father's policy of creating fortified burhs (towns) that could resist the onslaughts of the invading Danes. From CE 910 onwards, Aethelflaed created ten burhs in less than five years in various parts of Mercia. By early summer CE 913, she had constructed a fortified burh at the royal town of Tamworth, and by the end of the summer a burh had also been created at Stafford. Aethelflaed died in CE 918, and although a few individual burhs could be assaulted successfully, the system as a whole certainly worked. The Danes simply had insufficient resources to carry out protracted sieges, and the long-term Danish offensive threat was thus effectively neutralised.

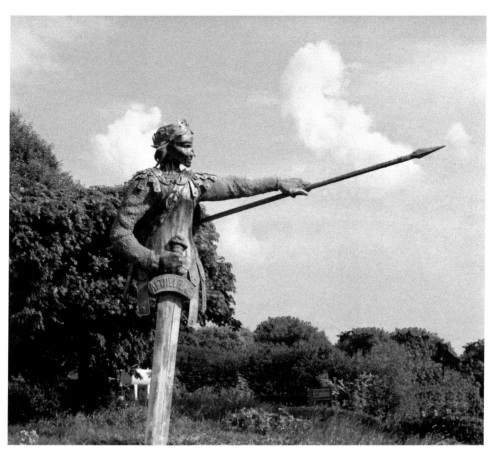

Statue of Aethelflaed at Tamworth station. (Courtesy of Annatoone)

Saxon military tactics were, in the long run, superior to the Danes. The same cannot be said, however, when Saxon military strategies are compared to those of the Normans. The Saxons were defeated at the Battle of Hastings in 1066 by a more sophisticated Norman army, divided into wings, which contained strong detachments of archers, mercenaries and heavy cavalry. In the late 1060s, much of Saxon England erupted in revolt against Norman rule. The Saxons of Staffordshire played a conspicuous role in these rebellions and together with forces from Wales, those elsewhere in Mercia and rebel leaders such as Eadric the Wild (a relative of Eadric Streona, who'd been a leading ealdorman of Mercia), they clashed with the Normans at the 1069 Battle of Stafford. William the Conqueror himself raced up to Staffordshire to confront the rebel army at Stafford, where the Saxon shield wall was destroyed by the might of the Norman military machine. After he'd scattered the rebels at the Battle of Stafford, William went on to take punitive action against the people of Staffordshire: settlements were burned down, crops destroyed, and peasants were killed.

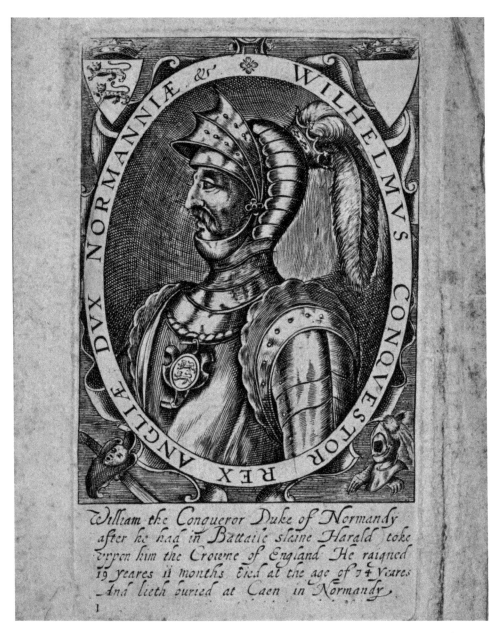

Fifteenth-century portrait of William the Conqueror. (© National Library of Wales)

In the aftermath of the 1069 rising, the Normans built a number of significant castles throughout Staffordshire in order to control and intimidate its sometimes rebellious population. These castles dominated the local landscape for centuries and their ruins remain part of Staffordshire's rich military heritage right up to the present day. To begin with, these castles were timber and earth motte-and-bailey constructions. The motte was the mound of raised earth on which the original

timber castle fortification was built, and this motte also had an outer courtyard or bailey that was enclosed by a wooden fence. By the twelfth century, however, many of these timber and earth fortifications had been replaced by stone. At Tamworth, Aethelflaed's tenth-century wooden ramparts formed the original basis of the castle built for Robert le Despencer in 1070. A castle was also built at Tutbury for the Norman Hugh de Avranches in 1071. Almost immediately, ownership of the castle was transferred to Henry, Lord of Ferrers and Chambrais, in Normandy. The castle was still owned by the same family in 1174, when William de Ferrers came into conflict with the Crown, and was besieged at Tutbury by Henry II, who subsequently ordered the castle's demolition (an order not properly fulfilled as the castle remained of strategic significance centuries later, during the period of the English Civil War). Stafford Castle was constructed in 1070 for Robert de Tosny, who later became better known as Robert of Stafford. De Tosny used the site of Aethelflaed's original CE 913 fortifications in order to construct his own castle at Stafford, which later became the seat of the powerful Stafford family.

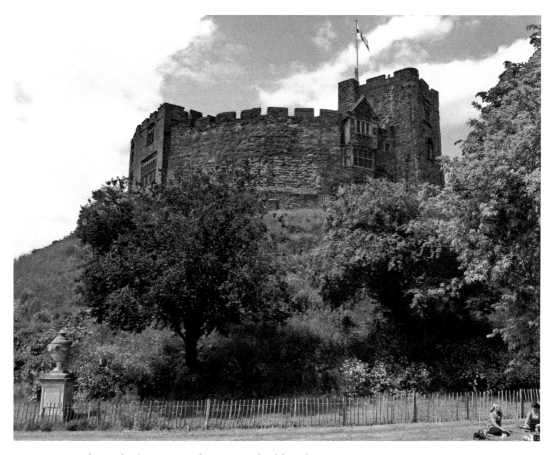

Tamworth Castle. (Courtesy of Tanya Dedyukhina)

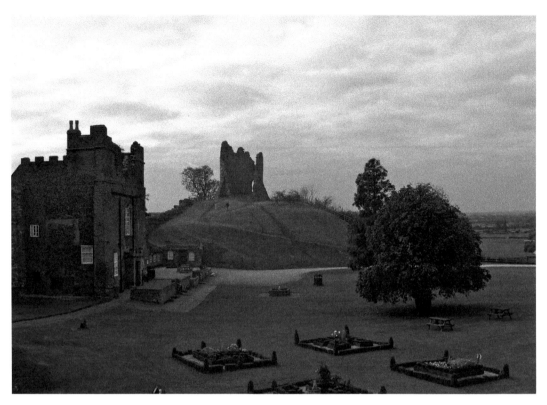

Tutbury Castle. (Courtesy of Dave Harris)

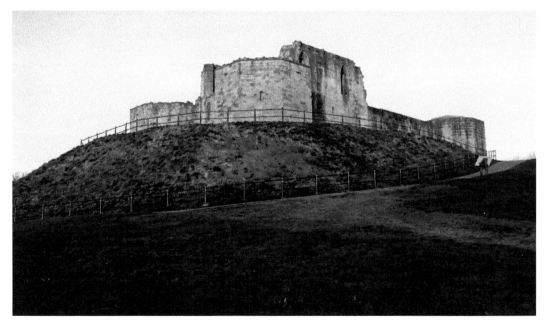

Remains of Stafford Castle. (Courtesy of Space-cadet-user)

2. Roses, Royalists and Parliamentarians

The so-called Wars of the Roses convulsed various parts of England for over thirty years, between the Battle of St Albans in 1455 and the final crushing of John de la Pole's Yorkist army at East Stoke in 1487. In sum, the wars were fought to decide which branch of the English royal family should rule the kingdom – either the house of Lancaster, with its red rose emblem, or the 'white rose' of the house of York. During the early part of this evolving dynastic struggle the county of Staffordshire became a focal point of conflict and Yorkist and Lancastrian armies clashed at the bloody Battle of Blore Heath, a few miles to the south-west of Newcastle-under-Lyme, on 23 September 1459. The Yorkists at Blore Heath were led by Richard Neville, Earl of Salisbury, who was leading a 5,000-strong army from Yorkshire through Staffordshire to link up with the leader of the Yorkist party, Richard Plantagenet, 3rd Duke of York, at Ludlow, in Shropshire. Both Salisbury and the Duke of York were then going to march onwards to Kenilworth Castle in Warwickshire in order to seize the weak and mentally unstable Lancastrian king, Henry VI. Meanwhile, Henry's queen, Margaret of Anjou, had dispatched a 10,000-strong Lancastrian army northwards under James Tuchet, Lord Audley, to prevent Salisbury's army from joining forces with the Duke of York. Audley finally managed to intercept the advancing Yorkists at Blore Heath, and his men positioned themselves on the south-west edge of the heath, with a small brook to their front.

The battle itself commenced with an inconclusive archery duel between the two sides. In the subsequent battle, Salisbury's smaller Yorkist army adopted a subtle, largely defensive posture. At the very beginning of the fighting the Yorkists feigned a retreat, which induced Audley to order a Lancastrian cavalry charge across the brook to their front. The militarily experienced Salisbury counter-attacked just as Audley's mounted troops crossed the brook, and a great number of Lancastrians were slaughtered. Audley was undeterred by this setback and ordered a second more successful frontal charge. Heavy fighting ensued, in which Audley himself was killed. Lord Dudley took over command of the Lancastrian army and continued with the same aggressive tactics used by Audley. He ordered a huge Lancastrian infantry assault of 4,000 men, which again ended in failure. At this point, roughly 500 of Dudley's troops changed sides, and the whole Lancastrian army seems to have disintegrated quite rapidly. Salisbury's Yorkists pursued the defeated Lancastrians throughout the night, leaving perhaps

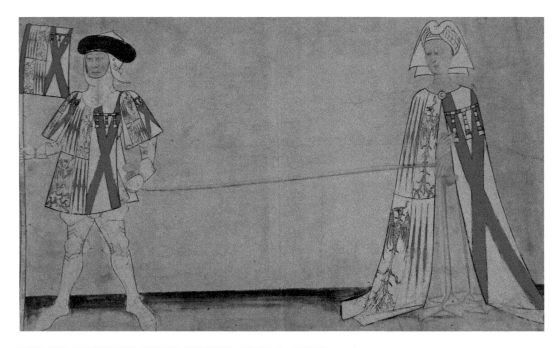

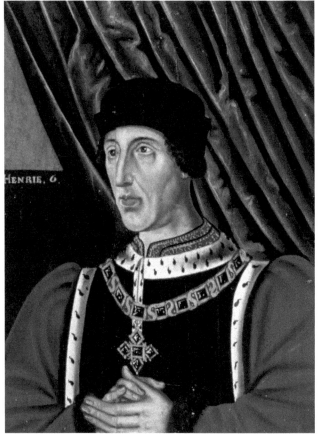

Above: Richard Neville and wife, from the 1463 Salisbury Roll.

Left: Henry VI. (© Dulwich Picture Gallery)

2,000 Lancastrian dead on the Blore Heath battlefield (the Yorkists lost around 1,000 men). The Earl of Salisbury was able to continue his march to Ludlow after the emphatic Yorkist victory at Blore Heath. However, the long-term effects of his Staffordshire victory were negligible. Henry VI and his queen sent a large army to Ludlow, which forced the Yorkists to capitulate, and Richard Neville, Earl of Salisbury, had to flee to Ireland. Moreover, at the end of 1460 Salisbury was defeated and captured (along with the Duke of York) at the Battle of Wakefield, and both men were subsequently beheaded by the victorious Lancastrians, in January 1461.

After Blore Heath, it was to be another 180 years before Staffordshire was again the scene of significant military activity and warfare. During the period of the English Civil War, between 1642 and 1649, the county was fought over by both Royalist and Parliamentary armies, and there were battles and sieges at Hopton Heath, Burton Bridge, Stafford, Lichfield, Tutbury and elsewhere. Tutbury Castle, near Burton-on-Trent declared for the king at the onset of war, survived a siege in 1643, and remained steadfast in its allegiance to the Crown until it was finally forced to surrender to Parliamentary forces (after a three-week siege) in April 1646. The castle was then dismantled on the orders of Parliament between 1647 and 1648. The town of Stafford, and nearby Stafford Castle, were also held by

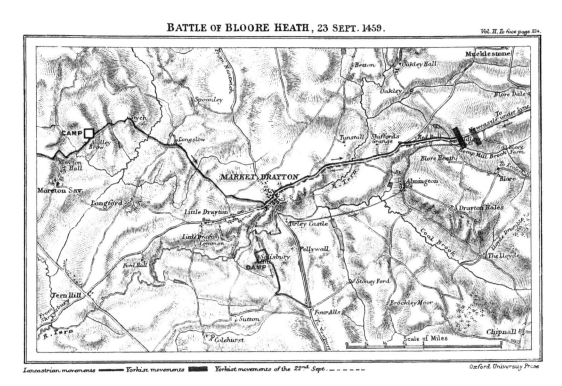

Map of Battle of Blore Heath, by James Ramsay, 1892.

Royalists at the onset of the war. Stafford town was captured by Parliamentary soldiers after a brief siege on 15 May 1643, but Stafford Castle continued to be held for the king by the redoubtable seventy-year-old Lady Isabel Stafford until it too fell into Parliament's hands in late June 1643. Parliamentary authorities finally ordered the destruction of Stafford castle on 22 December 1642. The cathedral city of Lichfield, like Stafford, was held initially by Royalists, though the city was certainly divided, between the ecclesiastical authorities who were sympathetic to Charles I and the wider town population who were often more in favour of Parliament. As a result of these differing sentiments, it was the cathedral precincts that became the heart of Royalist Lichfield, and during 1643 Cathedral Close itself was heavily fortified against attack. The cathedral area was the scene of much heavy fighting during the Civil War, which led to the destruction of the cathedral's central spire. In early 1643, Parliament began what proved to be a successful siege of Lichfield, led by Lord Brooke, who was the commander of Parliamentary forces in Staffordshire and Warwickshire. On 2 March 1643, Brooke was killed while leading the assault on the Royalist cathedral citadel and replaced by Sir John Gell, who was Parliament's County Committee leader. Gell's troops subsequently captured Cathedral Close, and the rest of Lichfield, but Parliament's triumph proved to be only temporary, as Prince Rupert's Royalist forces retook the city later in the year. Lichfield, including Cathedral Close, then remained in Royalist hands until Charles I's military position collapsed in 1646.

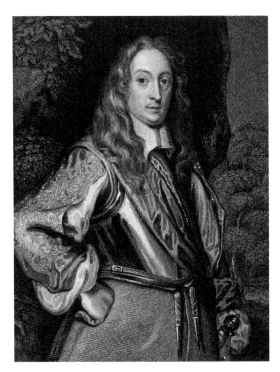

Lord Brooke, by W. Mote, 1640.

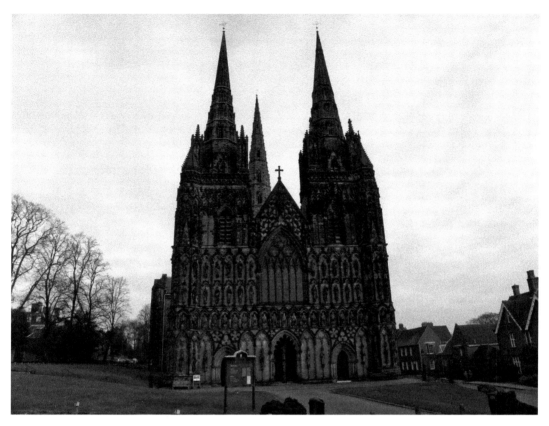

Above: Lichfield Cathedral and Close.
(Courtesy of Citterio)

Right: Prince Rupert of the Rhine, by
Gerard van Honthorst, 1630–56.

The undulating fortunes of Lichfield, which changed hands three times during the course of the war, pale into insignificance when compared with the situation in the small town of Burton-on-Trent which lay in the extreme south-east of Staffordshire, on the borders of Derbyshire. Burton had quite a large Puritan population at the start of the Civil War, with clear Parliamentary sympathies, and the town's thirty-six-arch medieval bridge provided a strategically vital crossing point over the River Trent. As a result, the town was frequently fought over by Royalists and Parliamentarians, and it changed hands on no less than twelve occasions during the Civil War period. Possession (or non-possession) of places like Burton-on-Trent Lichfield, Stafford and elsewhere also had a wider strategic importance for both Royalist and Parliamentarian armies, because Staffordshire lay across the crucial line of communications that connected the Royalist capital of Oxford with Yorkshire's east coast ports such as Bridlington, Scarborough and Hull. If Parliament could sever these communications by taking and holding towns like Stafford, then the Royalist war effort would be severely hampered. During 1643, the land route through Staffordshire, which connected Oxford with Bridlington, became even more crucial because Charles I's wife, Henrietta Maria, arrived at Bridlington with a massive cargo of military supplies for the Royalist cause, which needed transporting safely to Oxford.

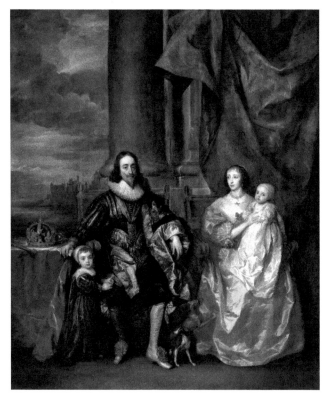

Charles I and Henrietta Maria, by Anthony van Dyck. (© Royal Collection)

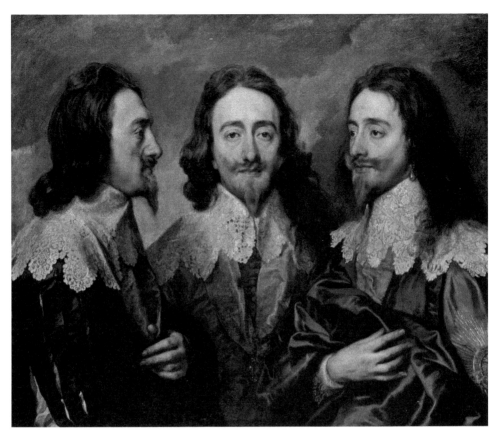

Charles I, by Anthony van Dyck. (© Royal Collection)

Early in the year, Brooke and then Gell intended the Parliamentary capture of Lichfield to act as a springboard for a further attack on the Royalist stronghold of Stafford, which was one of the key bastions along Charles I's Yorkshire–Oxford supply route. In order to attack Stafford, Sir John Gell needed reinforcements, and for this purpose he agreed to link up with the Cheshire Parliamentary forces commanded by Sir William Brereton. The two Parliamentary generals agreed to bring their forces to Hopton Heath, just a few miles to the north-east of Stafford, on 19 March 1643. In the meantime, Charles I had sent a Royal army under Spencer Compton, 2nd Earl of Northampton, to seize control of Staffordshire and the West Midlands. Like Gell, Compton also sought reinforcements, and he linked up with Royalist forces commanded by Henry Hastings, at Tamworth, before entering Stafford on 18 March. The Royalists became aware of the presence of the Parliamentary army at Hopton Heath at some point during the mid-morning of the 19th and moved out to confront Gell and Brereton's army in one of the very few set piece battles to take place in Staffordshire during this period.

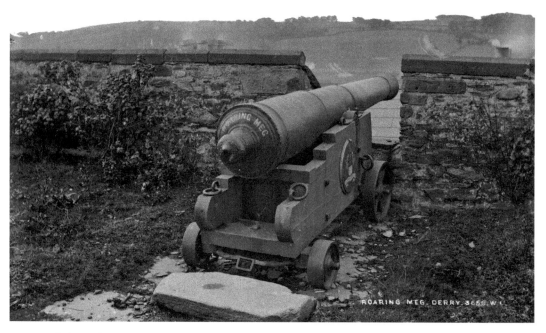

English Civil War Roaring Meg cannon, later sent to Derry. (© National Library of Ireland)

The Royalists attacked the Parliamentary army at Hopton Heath in the late afternoon, with about 1,200 men (composed of mostly mounted infantry dragoons and lighter armed cavalry). By contrast, roughly half of the Parliamentary army of 1,400 men was composed of infantry, with 300 dragoons and 400 cavalry making up the rest of the force. The Royalists immediately took the initiative in the battle, with Hastings attacking the flanks of Parliament's army with his dragoons. Royalist artillery pieces (including a 29-pounder nicknamed Roaring Meg) also pummelled the Parliamentary army. Spencer Compton followed up Hastings' success in pushing back the flanks of Parliament's army by attempting to smash the centre of the Parliamentary formation with two all-out cavalry charges. Gell and Brereton's infantry stood firm, however, and the Royalist cavalry failed to make a breakthrough. Moreover, in the second Royalist charge Compton was unhorsed and killed by Parliamentary troops. Another Royalist commander, Sir Thomas Byron, then led an equally fruitless third cavalry charge against Gell and Brereton's positions, before a final Parliamentary infantry attack pushed the Royalists away from Hopton Heath. Parliamentary losses during the battle were probably in the region of 500 men, while the Royalists lost perhaps just fifty men.

By nightfall on 19 March the Parliamentary army was left in sole control of the battlefield. Even so, both sides claimed Hopton Heath as a victory. Shortly after the battle, however, Parliament's Sir John Gell left for Derby and William Brereton returned to Cheshire. For the following month or so the Parliamentary objective of seizing Stafford was also abandoned. Thus, it's probably best to see the Battle of Hopton Heath as being a minor but clear strategic victory for the Royalist side. By mid-May 1643, Stafford was again in the hands of Parliament, but by this time the Royalists were preoccupied with clearing areas of south Staffordshire in order to ensure the safe transit of Henrietta Maria's arms supplies through the county. Prince Rupert was sent from Oxford with a force of 1,200 cavalry, 700 infantry and six cannons to clear the route for the queen. Rupert's military capabilities were somewhat tarnished later on (at least in Charles I's eyes) by his reckless actions at the 1644 Battle of Marston Moor, and by his loss of the vital Royalist port of Bristol in 1645. However, in 1643, Prince Rupert's south Staffordshire campaign was undoubtedly a success. His army forced Parliamentary garrisons at Birmingham and Rushall (which was on the road between Walsall and Lichfield) to surrender, and on 21 April he accepted the surrender of Colonel Russell and the Parliamentary garrison at Lichfield. Rupert placed Royalist garrisons in key towns along the route taken southwards by Henrietta Maria and her desperately needed convoy of military supplies. The success or failure of the whole enterprise really depended upon whether or not the advancing Royalists could get their supplies across the River Trent at the vital bridge crossing at Burton-on-Trent. The medieval bridge at Burton was guarded by a Parliamentary garrison under the command of Captain Thomas Sanders and Colonel Richard Houghton (who was the military governor of Burton town). On 4 July, a brief but nonetheless important battle was fought at the bridge, which resulted in an emphatic victory for the Royalist side. Colonel Thomas Tyldesley led a cavalry charge across the bridge that drove the Parliamentarians back and succeeded in capturing both Sanders and Houghton. Henrietta Maria was able to move onwards with her supplies through Walsall, and she was eventually able to deliver in Oxford all the weapons and ordnance originally unloaded in Bridlington. The significance of the events at Burton Bridge was certainly recognised by Charles I, who promoted and knighted Thomas Tyldesley as a reward for his efforts. Tyldesley's efforts meant that the Royalists were able to establish a significant garrison in the town, but this garrison was later forced to surrender to the superior Parliamentary forces of Sir John Gell in January 1644, when 500 Royalist prisoners were taken. The town and its bridge changed hands a further seven times during the following two years, until Parliament's forces finally took control, once and for all, in early 1646.

3. Staffordshire's Fighting Foot

In 1696, William III created an order of precedence within the Foot (infantry) regiments at the disposal of the Crown. He did this in order to end arguments and disputes between army commanders about seniority, and who could give orders to whom. The most senior Foot regiment was given the number '1', followed by the 2nd Foot, 3rd Foot and so on. Seniority was judged by the length of time a particular regiment had given service to the English Crown. The county of Staffordshire became linked to four Foot regiments, namely the 38th, 64th, 80th and 98th Foot, and eventually the 38th and 80th Foot were transformed into the South Staffordshire Regiment, while the 64th Foot and 98th Foot merged to become the North Staffordshire Regiment. The links between the four Foot regiments and the county varied in length of time and intensity. The 38th Foot, for example, was raised in the city of Lichfield in 1705 (after a few previous abortive attempts) by Colonel Luke Lillingston. It initially recruited men from Lichfield, and the rest of Staffordshire, but by the end of the century, recruits were arriving from much further afield.

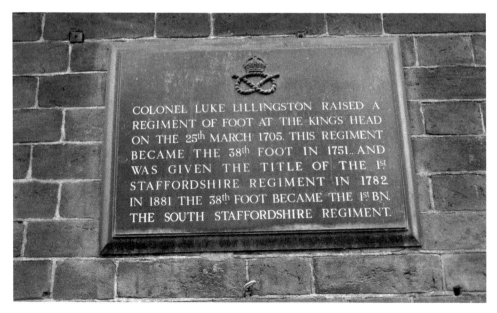

Plaque commemorating the raising of the 38th Foot in Lichfield. (Courtesy of Harry Mitchell)

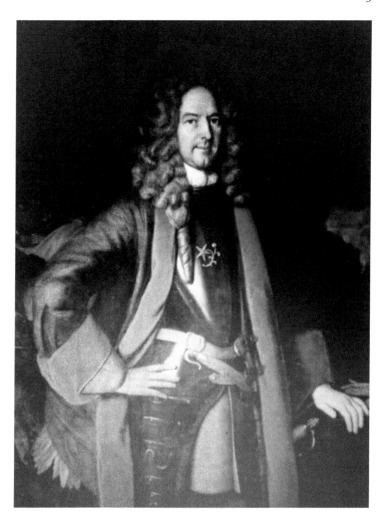

Luke Lillingston, unknown artist, *c.* 1715. (© ArtUK)

Eighty-eight years later, in 1793, the 80th Foot was founded, largely in response to the perceived threat posed to Britain by the outbreak of the French Revolution. The regiment was founded by Henry William Paget, who became the 2nd Earl of Uxbridge, and was commander of the British and allied cavalry at the Battle of Waterloo. Paget is perhaps best remembered for his *sang froid* at Waterloo, when a cannonball ripped off his leg as he watched the battle on horseback next to the Duke of Wellington. 'By God sir, I've lost my leg,' he is alleged to have said to Wellington. In restrained fashion, Wellington leaned over and apparently commented, 'By God sir, so you have.' The grisly remains of the Uxbridge leg were amputated, from the mid-thigh downwards, without anaesthetic. 'The knives appear somewhat blunt' was Uxbridge's only comment during the operation, which was a clear success. Paget went on to live a full life for the next thirty-nine years, passing away at the ripe old age of eighty-five in April 1854.

Henry Paget, by Peter Stroehling, 1768–1826. (© Royal Collection)

The men for Paget's new 80th Regiment were recruited largely from those living on the estates of his father, the 1st Earl of Uxbridge, and from the Staffordshire Militia. The militias of the realm were the country's traditional defence forces and were used as the main aid to the civil power during times of internal disorder. By the end of the eighteenth century the Staffordshire gentry were leading an enthusiastic county militia service, which was keen to resist a French invasion. In 1797, it was inspected in person by George III, who was so impressed by the appearance of the militia troops that he ordered them to Windsor Castle for royal duties. The Staffordshire Militia was then invited back to Windsor Castle for further royal duties in 1799, 1800, 1801 and 1803. Paget was successful in persuading many experienced local militia men to volunteer for his new army regiment. Additionally, he gathered recruits from the Staffordshire Volunteers, a military unit originally raised in 1798 to counter the threat of invasion by the French. Following the temporary cessation of hostilities against the French in 1802, the Staffordshire Volunteers were disbanded. The former Volunteers then chose to be merged with the 80th Foot, and from this point onwards the 80th became known as the 80th Regiment of Foot (Staffordshire Volunteers). The 64th and the 98th

Foot regiments didn't originate in Staffordshire (unlike the 38th and 80th Foot). The 64th Foot was originally a Hampshire regiment, founded in Southampton in 1756. However, one of the consequences of British defeat in the American War of Independence was a change in army policy: In order to boost recruitment and develop a greater sense of *esprit de corps* among troops, more emphasis was placed upon regionalism and territorial identification. Thus, it was thought that men would fight better for a county or area that they knew, rather than for just a regiment with a number. As a result, the 64th Foot was linked to Staffordshire in the early 1780s and became known as the 64th (2nd Staffordshire) Foot. The regiment also began its long association with Lichfield by establishing depot companies in the city, and these depot soldiers soon began to wear the emblem of the Staffordshire knot on their uniforms. The 98th Foot's early links with the county of Staffordshire were even more tenuous than those of the 64th Foot. The 98th was actually a Sussex regiment, raised by Lieutenant-Colonel Mildmay Fane in 1824. It wasn't until the early 1870s, during the period of the Cardwell army reforms, that members of the regiment first received news that they were to be more closely linked with the county of Staffordshire. One key aspect of the Cardwell reforms – embodied within the 1871 Regulation of the Forces Act – was the proposal that single battalion regiments should be linked together, with a single depot and recruiting district within the UK. These new larger regiments were to be based in a specific Regimental District, from which the majority of their new recruits were to be drawn. The 98th Foot was based in Ireland in the early 1870s, when it first learned that it was to be merged with the 64th Foot, and based at Whittington Barracks, Lichfield, as part of Regimental District No. 20. The Cardwell reforms were, however, quite controversial and aroused considerable opposition within the army as a whole. Thus, it wasn't until the passage of the 1881 Childers reforms that the 98th and the 64th Foot were finally merged to become the Prince of Wales (North Staffordshire) Regiment.

The four Foot regiments attached to Staffordshire by the early 1870s were, at one time or another, posted to countries in virtually every continent of the world – from Europe and Africa to North America, South America, the Middle East, Australia and the Far East. The eighteenth and nineteenth centuries saw a massive increase in the size of the British Empire, and Staffordshire's Foot regiments were often posted, for considerable periods of time, on garrison duties in far flung outposts of this burgeoning empire. Garrison duties could on occasions be just as dangerous as active service. The 38th Foot, for example, were garrisoned on the plantation dominated Leeward Islands, in the Caribbean (mostly in Antigua) for forty-nine years, between 1716 and 1765. During this time, illness and disease ripped through the regiment. During just one seven-year period of this long Caribbean posting, 1,068 men were lost to the ravages of yellow fever and other tropical diseases. So scarce were clothing supplies from the UK, and so hot was

the climate, that the 38th Foot became the first British regiment to devise for itself a primitive tropical uniform, using locally sourced Holland fabric from sugar sacks to line soldiers' coats.

On Active Service

For all four Foot regiments linked to Staffordshire between 1705 and 1881, garrison duties were interspersed with active campaigning in many of the major wars of the period. The 38th Foot, for example, fought throughout the entire course of the American War of Independence. It participated in the British defeat at Bunker Hill in 1775, and also fought in the lesser-known British victory at the Battle of Brandywine, in Pennsylvania, during 1777.

Within ten years of British defeat in the American War of Independence, Staffordshire's Foot regiments were engaged in a far more widespread and convoluted struggle against the French. With only a short gap between 1802 and 1803, Britain was at war with France for twenty-two years between 1793 and 1815. The 38th Foot's greatest contribution to Britain's long war against France lay in its involvement, from the very start, in the Peninsula War of 1808–14. The Peninsula War was an epic, sometimes bloody campaign fought by the British – aided by Spanish and Portuguese forces – to rid the Iberian Peninsula of its French invading forces. The 38th fought in the opening battles of 1808, in

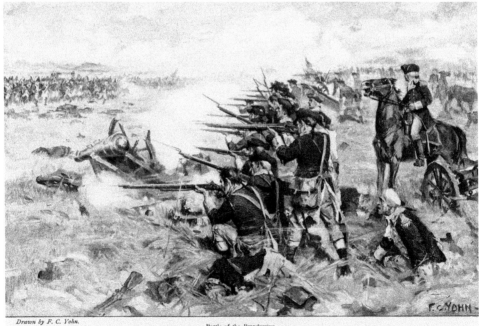

Drawn by F. C. Yohn.
Battle of the Brandywine.
Many of the Americans were unskilled militia but they repelled charge after charge of the infantry, chasseurs and grenadiers.

Battle of Brandywine, by F. Yohn, 1898.

Brandywine memorial, 1920. (Courtesy of Stauryo1)

Portugal, at Rolica and Vimeiro, and it was still there in 1814, when the allied army commanded by Wellington forced its way over the Pyrenees and into southern France. In between, the regiment fought in some of the bloodiest and most famous battles of the campaign. In 1812, it was part of the British force that stormed the vast French fortress of Badajoz, on the Portuguese border, at terrible cost (nearly 5,000 British soldiers were lost during the siege).

On 22 July 1812, the regiment was involved in Wellington's triumph at the Battle of Salamanca, when British forces decimated the cream of Marshall Marmont's French army in less than four hours. On 21 June 1813, the 38th was again present, at the Battle of Vitoria, when the British and their allies, under Wellington, defeated the French army under Marshall Jourdan and Joseph Bonaparte. During the long wars against France, Britain also fought a whole host of other countries (often at the same time) including Spain, the Dutch, Denmark and America. In order to defeat its many enemies Britain adopted a global strategy, at the heart of this strategy was an attack on the colonies of its enemies. Staffordshire's 38th, 64th and 80th Foot regiments played notable roles in this global British response: the 38th and the 64th, for example, were instrumental in the capture of Martinique from the French in 1794, St Lucia in 1796, and Trinidad in 1797.

Siege of Badajoz, by Richard Caton Woodville. (© National Army Museum)

The 80th were sent to Egypt in 1801 as part of a force sent to expel French forces from the strategically vital Suez Isthmus area. In 1804, the 64th Foot moved to the South American mainland, where it helped capture Dutch Surinam (on the north-east coast). Men from the 38th Foot also ventured much further south and fought the Spanish in Montevideo and Buenos Aires, during 1807. In addition, the 38th and 80th Foot played a major role in seizing the southern African Cape of Good Hope from the Dutch.

After Wellington's triumph at Waterloo in 1815 the victorious British kept their colonies, and for the next hundred years Britain was involved in only one major European war – the Crimean War against the Russians. The 38th Foot was heavily involved in the campaign against the Russians, fighting at the Alma and Inkerman in 1854, and at Sevastopol in 1855. For the most part, however, Staffordshire's Foot regiments were engaged in policing and expanding the British Empire. During the first thirty years or so of Queen Victoria's reign Britain's Indian empire expanded considerably, and Staffordshire's Foot regiments made a notable contribution to this expansion. British India at this time was run by a vast private company, the East India Company (EIC), in close cooperation with the British government. The EIC expanded its Indian territories quite aggressively during the early part of the nineteenth century, making full use of troops supplied by the British Crown.

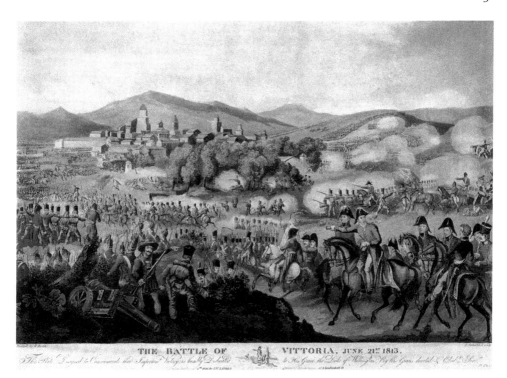

THE BATTLE OF VITTORIA, JUNE 21ST 1813.

Above: Battle of Vitoria. (© ASK Brown Collection)

Right: 64th Foot officer, by John Buncome, 1805.

In 1845, EIC troops invaded the Punjab (thereby beginning the Anglo-Sikh Wars, which lasted until 1849). The Sikhs had a 70,000-strong, trained army called the Khalsa, which provided stern opposition for the British forces (including Staffordshire's 80th Foot) commanded by Sir Hugh Gough. Gough had little grasp of sophisticated military tactics, and as a result British battle casualties were often very high. The 80th fought the Sikh Khalsa at the battles of Mudki and Ferozeshah in December 1845, and at Sobraon in February 1846. During the ferocious two-day Battle of Ferozeshah, the 80th launched a bayonet charge at Sikh gun positions which proved to be crucial in securing a hard-fought victory for Gough. By 1849, the EIC had successfully annexed the Punjab. The company's plans for expansion, however, extended well beyond the Indian frontier. In 1852, an EIC army, which included the 80th Foot, invaded Burma and seized the key province of Pegu. In 1856, the EIC also went to war with Persia, and the 64th (2nd Staffordshire) Foot was part of an army that fought a brief three-month campaign in the region.

Portrait of Sir Hugh Gough.
(Courtesy of Dubheire)

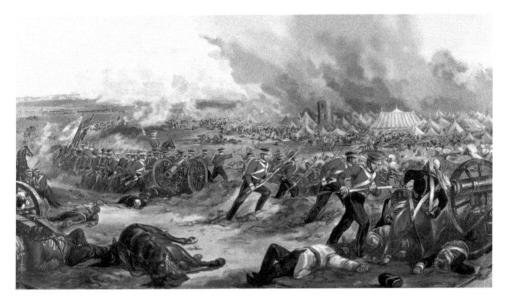

Battle of Ferozeshah, by Henry Martens, 1847.

The greatest challenge to EIC and British rule in India was undoubtedly the First War of Indian Independence of 1857–58. The revolt against British rule sprang up across northern and central India, with its epicentre in Bengal. There were atrocities on both sides, and to begin with British forces were severely outnumbered and had little option but to retreat behind garrison walls in places such as Lucknow and Cawnpore. The 64th Foot became part of a small force under Sir Henry Havelock, which tried unsuccessfully to save the garrison at Cawnpore. By the time they arrived at the deserted British positions, in July 1857, the entire garrison had been slaughtered. However, most of the regiment remained at Cawnpore, and it was here in November that drummer boy Thomas Flynn won the regiment's only Victoria Cross (VC) for engaging two rebel artillerymen in combat while being severely wounded himself – Flynn's achievement was a fine one because, ever since its institution in 1856, the VC has been recognised as the ultimate award for gallantry in battle by members of Britain's armed forces. The 38th Foot also arrived in India, from Ireland, and took part in the final (and successful) relief of Lucknow in 1858. In addition, the 80th Foot was posted to India in February 1858, and took part in what became known as the Central India Campaign, in which British and Indian troops (commanded by Sir Hugh Rose) overcame a series of rebel states and armies during one rapid campaign. By this time it was clear that the rebellion was heading for defeat, but mopping-up operations against the rebels continued until well into 1859. British India would never be the same again. EIC authority was ended in 1858, and after this date Staffordshire's soldiers would fight in an India ruled directly by viceroys and representatives of the British government.

VIEW OF CAWNPORE FROM THE RIVER.

MAJOR GENL SIR HENRY HAVELOCK, K.C.B.

From authentic Portrait in the possession of the Family.

Above: Cawnpore, by M. Montgomery, 1858.

Left: Engraving of Sir Henry Havelock, *c.* 1850. (© Library of Congress)

From the 1860s onwards, Africa rather than India and Asia became the main focus of imperial expansion. This shift in emphasis can be shown by the fact that of fifteen Victorian wars fought after 1861, ten took place in Africa. One of the best known (and most written about) of these African conflicts was the Zulu War of 1879, which began when Lord Chelmsford led a British invasion force into Zululand during January 1879. The central column of this invasion force was largely wiped out by a huge Zulu impi of roughly 20,000 men at the Battle of Isandlhwana. Staffordshire's Foot regiments weren't present in company or battalion strength at Isandlhwana, but individual soldiers were involved. The 80th Foot privates Wassall and Westwood, for example, took part in the fighting, and Samuel Wassall, a former bricklayer from Dudley, was awarded a VC for rescuing Westwood under fire from the Zulus during their escape from the battlefield. The 80th Foot were more closely involved in some of the war's other battles. Long British supply columns were in constant danger of being ambushed by the Zulus, and in March 1879 one such column, led by men of the 80th, was attacked on

Battle of Intombe. (*Illustrated London News*, 1879)

the banks of the River Intombe. The supply column's commander was killed and his second-in-command, Henry Hollingsworth Harward, controversially left the battlefield on horseback – allegedly in order to seek reinforcements. The men he left behind at Intombe were commanded by the 80th's Colour Sergeant, Anthony Clarke Booth, who was later awarded a VC for leading roughly forty survivors back to safety at Raby's Farm, near Luneberg. The final battle of the Zulu War was fought at the Zulu capital of Ulundi, in July 1879, and the 80th Foot played a key role in this closing confrontation. The regiment was employed as part of Sir Evelyn Wood's independent Flying Column, and at Ulundi five companies of the 80th made up the leading face of the British infantry square (supported by cavalry), which faced repeated mass attacks from the Zulus. The result of the battle was never much in doubt. Volley fire from the 80th, supported by Gatling guns, mowed down the advancing Zulus, and the power of the Zulu military machine was broken forever.

Sir Evelyn Wood, by Bassano, 1916.

Pencil sketch of
Lord Chelmsford at
Ulundi, 1879.

4. For Home and Hearth

The Staffordshire Yeomanry, composed of part-time 'citizen' cavalrymen, was formed at the Swan Hotel in Stafford during 1794 in response to the perceived threat of invasion from Revolutionary France. The new regiment's Latin motto was *Pro aris et focis*, which translated literally meant 'for altars and hearths'. The motto was, however, more commonly interpreted as meaning 'for home and hearth', which summed up the reasons why many joined the yeomanry in its first days – to defend Staffordshire and the homeland against a possible French attack. The Staffordshire Yeomanry was dominated from the very start by the aristocracy and gentry, who made up its officer cadre, and by local men (often tenants of the local lords and gentlemen) who had access to their own horses. Its first commanding officer was George Granville Leveson-Gower, who was the first Duke of Sutherland and reputedly the richest man in Britain. Another prominent local gentleman, Robert Peel (future Home Secretary, Prime Minister, and founder of the Metropolitan Police force), was also an officer in the Staffordshire Yeomanry during 1820.

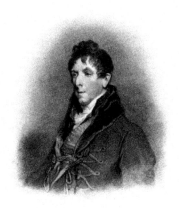

Portrait of George Leveson-Gower
by Henry Meyer, 1780–1847.
(© National Library of Wales)

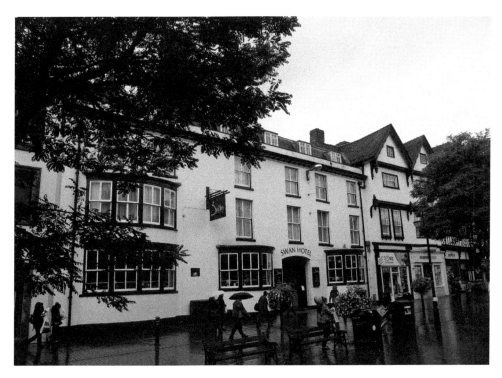

Above: Swan Hotel, Stafford. (Courtesy of Guy Cockin)

Right: Robert Peel, by R. Scanlan (1801–76).

Leveson-Gower's Staffordshire Yeomanry troops must certainly have made an impressive sight as they rode about the county in the late 1790s, dressed in red jackets with yellow facings, white waistcoats, and white leather breaches and military boots. All this finery was topped with a bearskin crested helmet (with a feather to one side), and the cavalrymen were armed with a sword and pistol. During the course of the Victorian era, the predominant colour of the Staffordshire Yeomanry uniform changed from red to blue, with scarlet facings and silver lace, but the cavalrymen still remained a spectacular sight as they moved through the towns and villages of the county. The Staffordshire Yeomanry was divided into troops and, to begin with, these troops were linked to the towns of Newcastle-under-Lyme, Stafford, Lichfield, Leek and Walsall. Later on, other towns were also allocated troops, and there were usually about forty men in each troop (with the addition of two officers in charge of each formation).

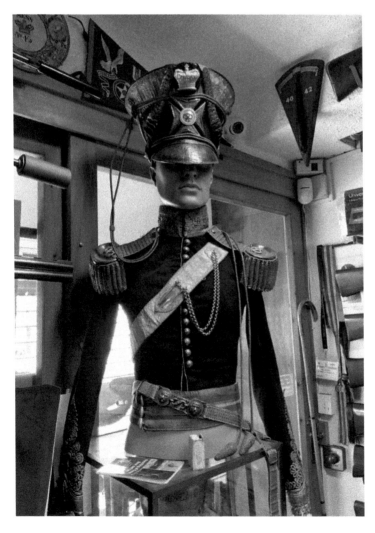

Staffordshire Yeomanry uniform, 1837. (© Lesmartin Militaria)

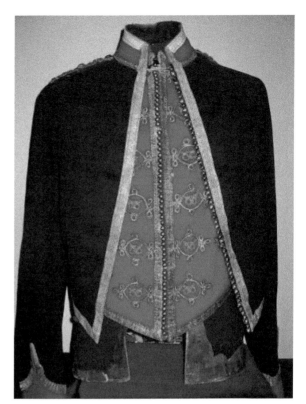

Right: Staffordshire Yeomanry
1st pattern officer's mess jacket.
(© Lesmartin Militaria)

Below: Staffordshire Yeomanry
Victorian full dress pouch.
(© Lesmartin Militaria)

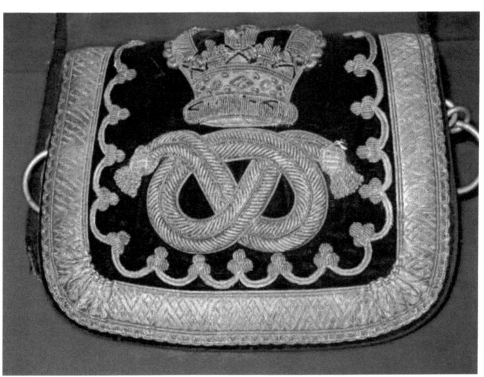

The initial regimental objective of defending 'home and hearth' against French invasion quickly became irrelevant after Napoleon's defeat at Waterloo in 1815. Instead, the regiment's main priority quickly became that of supporting the civil powers in maintaining internal law and order, and suppressing riots and disturbances. Within a year of its creation in 1794, the Staffordshire Yeomanry was engaged in suppressing bread riots, and in 1831, during the tumultuous days leading up to the passage of the 1832 Great Reform Act, the regiment was deployed to Derbyshire in order to deal with various riots and disturbances. The conduct of the Staffordshire Yeomanry in dealing with these Derbyshire problems certainly met with the approval of the government. On 22 October 1831, the Home Secretary, Lord Melbourne (later Queen Victoria's first Prime Minister), wrote from Whitehall to Lieutenant-Colonel Littleton, the Staffordshire Yeomanry Commandant, commending the behaviour and actions of the regiment in Derbyshire, and his letter was published in full in the *Staffordshire Advertiser* seven days later.

Portrait of Lord
Melbourne, 1844.
(© National Liberal Club)

In 1838, the Staffordshire Yeomanry was given the title of the Queen's Own Royal Regiment, following an earlier successful royal visit to the county. In 1842, the new Queen's Own Staffordshire Yeomanry was again suppressing riots and disturbances, this time in the Potteries area. Chartist pressure for political reform seems to have been particularly acute in Stoke (policed by the yeomanry's Lichfield troop) where disturbances were still taking place in the summer, long after order had been restored in other parts of the county. During the course of the nineteenth century, as regional police forces expanded, the role of the yeomanry in supporting the civil powers diminished considerably. As a consequence, some yeomanry formations began to decline, but this certainly wasn't the case in Staffordshire, where the Staffordshire Yeomanry maintained a highly visible presence in the county throughout the mid- and late nineteenth century. Of course, the Staffordshire Yeomanry, like other yeomanry regiments, was never intended to serve overseas. Its cavalrymen could often be seen around the county, engaged in one activity or another, which made them very different from the county's infantry regiments (often based overseas for years at a time, with only a token depot presence in Lichfield). Staffordshire Yeomanry activities were often well publicised in the local press. The yeomanry's annual rifle shooting competition took place at Sedgley Park Rifle Range, near Cannock, during August 1901, and was reported upon by the *Cannock Chase Courier* newspaper. Cavalry drill exercises also proved to be noteworthy, and during April 1885 the first mounted drill performed by the Walsall and Wednesbury troop of the Staffordshire Yeomanry was written about by the *Wolverhampton Express & Star.* Staffordshire Yeomanry balls proved to be particularly popular and presented an opportunity for both civilians and yeomen to mix together in convivial surroundings. Substantial balls took place in Lichfield, which could be attended by officers and men from the entire regiment, but individual troops and squadrons also held their own annual balls (such as the ball for C Squadron which took place at St Paul's Institute, Burton, in January 1910). The highlight of the year for many yeomen was attendance at the Staffordshire Yeomanry's annual summer training camps. Between the mid-1830s and the 1910s these camps took place at a variety of locations within Staffordshire, including Whittington Heath near Stafford, Lichfield, Trentham Park, Keele Park, Cannock Chase and Himley near Wolverhampton. Camps could last from just a few days to roughly three weeks in duration and could involve a variety of activities, from the presentation of new colours (as in 1835) to the various horse and sword competitions that ended the 1895 annual training camp at Lichfield. These annual Staffordshire Yeomanry get-togethers were events of considerable importance to the county as a whole. The presence of hundreds of troops, billeted in hotels and public houses, who were undertaking their annual training exercises, or on their way to training camps, gave the county a considerable economic boost. In May 1909, for instance, seventy-three officers

and men from C Squadron (Burton and Uttoxeter) Staffordshire Yeomanry were billeted at the White Hart, the White Horse, the Cross Keys, the Old Talbot and various other hostelries in Uttoxeter while on their way to the annual training camp at Trentham. These men paid for their lodgings, food and drink, and flooded the small town in what the local press of the time regarded as being a rather good-natured 'invasion' of Uttoxeter. Relations between civilians and cavalrymen were, however, sometimes very strained during these periods of annual summer camp training. During the 1883 Lichfield summer camp, allegations were made that during one particular function officers pelted the bishop, dean and canon of Lichfield with oranges so ferociously that the clergymen were forced to flee from the scene. During the same training period, Staffordshire Yeomanry officers also allowed some very 'objectionable persons' to attend the yeomanry ball (at least according to the London *St James's Gazette*). The yeomanry were again based in Lichfield for one week's training during summer 1884. All the regiment's leading figures were based in the town during this annual training period, including its commanding officer, William Bromley-Davenport, the Marquess of Anglesey, and the Staffordshire Yeomanry Adjutant, Major Graves. The officers' mess was established at the Swan Hotel, and other officers and men were billeted at various establishments throughout Lichfield.

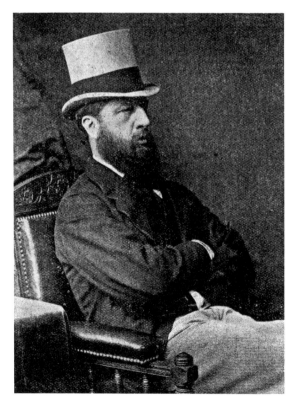

Photograph of Lord Hartington by Bassano, *c.* 1900.

Lichfield's Samuel Johnson statue, donated in 1838. (Courtesy of Elliot Brown)

During three nights in early June, drunken yeomanry officers and men indulged in widespread riotous behaviour. The D'Oyly Carte opera company were accosted after a performance at St James Hall. Later on, Samuel Johnson's statue was defaced, and there were numerous brawls between yeomen and police. On the last night of disturbances in the town centre, there were angry confrontations between local residents and the yeomanry, and William Bromley-Davenport died of a heart attack as he was trying to bring an end to the ugly scenes. News of the Lichfield disturbances made headlines across Britain, and Lord Hartington, who was the Liberal government's Secretary of State for War, was forced to answer questions relating to the conduct of the Staffordshire Yeomanry in the House of Lords.

The Yeomanry at War
The events of 1884 in Lichfield were an undoubted aberration. Between 1884 and 1899, the Staffordshire Yeomanry continued with its cycle of training activities and seems to have co-existed in reasonable harmony with the civilian

population of the county. At the end of 1899, however, after 105 years of domestic operations, confined exclusively to Staffordshire and its neighbouring counties, elements of the Queen's Own Staffordshire Yeomanry were posted overseas to fight the Boers of South Africa. The Boer War of 1899–1902 pitted Britain against the tenacious Dutch Boer farmers of the Transvaal and the Orange Free State, in southern Africa. A war between the expansionist British, who were keen to add to their southern African dominions, and the Boer settlers, who were determined to maintain their independence, was probably inevitable. To begin with the Boers were very successful, defeating the British in a number of key battles and besieging the British-held towns of Mafeking and Ladysmith. Initial Boer military successes were entirely predictable, given the fact that they could mobilise (in theory) at least 85,000 men, equipped with rifles and horses. By contrast British forces in southern Africa numbered perhaps only 10,000 men. To be victorious against the Boers, the British needed more men. As a result, on Christmas Eve 1899 a royal warrant was issued requesting that yeomanry regiments across the country send companies of 115 men to fight against the Boers. These yeomanry regiments were destined to serve in a new volunteer mounted formation of the British army called the Imperial Yeomanry, which officially came into being on 2 January 1900. The Staffordshire Yeomanry provided one company of men for the 4th Battalion of the new mounted force in 1900, and another company for the same battalion in 1901. The war fought by the Staffordshire Yeomanry, as part of the Imperial Yeomanry, proved to be a bitter and bloody one, in which the mobile Boers adopted highly effective guerrilla tactics. In order to achieve final victory, the British resorted to the widespread burning of Boer crops and farms, and the imprisonment of thousands of Boer families in some of the world's first concentration camps. Eventually, the Boers were starved into submission, though reasonably generous peace terms were offered by the British – and accepted by the Boers – in the 1902 Treaty of Vereeniging, which ended the conflict. The Imperial Yeomanry certainly played its part in securing the final British victory. It saw more fighting than any other auxiliary force present during the war and suffered 3,771 casualties, 50 per cent of which were sustained in action (a higher casualty rate than that sustained by even the regular British cavalry).

By the time of the outbreak of the First World War in 1914, the role and position of yeomanry forces within the British army structure had changed yet again, as a result of the 1907 Territorial and Reserve Forces Act. This particular Act merged all yeomanry forces into a new Territorial Force intended for home service within the UK. As a result of the Act no Staffordshire yeoman could be compelled to serve overseas in the event of a future war. They could instead volunteer for what was called 'Imperial Service' in defence of the interests of the British Empire. The implications of the 1907 Act could certainly be seen in the arrangements

The Base Hospital of the Imperial Yeomanry is at Deelfontein, where it has 625 beds. Deelfontein, which is situated twenty-nine miles south of De Aar, is a small place, with no station proper, but consists of a siding and pumping station. Our photographs are by J. Hall Edwards

NO. 7 TENT OF THE IMPERIAL YEOMANRY HOSPITAL AT DEELFONTEIN

Imperial Yeomanry soldiers at a Boer War hospital. (© Wellcome Collection)

made for utilising the Staffordshire Yeomanry during the First World War. During August and September 1914, Territorial Force yeomen were divided into three tiers. The first tier was liable for active service overseas; the second tier was composed of those unable or unwilling to serve overseas (and therefore earmarked for home service); and a third tier acted as a reserve, supplying replacements to the other two tiers. The Staffordshire Yeomanry's third tier was formed in 1915 and spent the rest of war as a Reserve Cavalry Regiment based in Aldershot. The Staffordshire's second tier, formed in 1914, had a more varied record of home service during the war years, based in Norfolk, Essex and then Kent. For the majority of the time the tier remained on horseback, but between July and November 1916, and then from May 1917 onwards until the end of the war, the yeomen swapped their horses for bicycles when they became part of the army Cyclist Division. Without doubt, the first-tier men, who could be used to fight Britain's enemies in any part of the world, were the key element in the Staffordshire Yeomanry's overall contribution to the British war effort. Men who were prepared to fight abroad were prize recruits for the yeomanry. Hence, it was no surprise that when the Staffordshire Yeomanry advertised for recruits in the *Burton Chronicle* of 1 October 1914, it specified that it wanted men who were 'willing to serve anywhere'. After some brief training in Diss, Norfolk, the first tier of the Staffordshire Yeomanry was shipped to the Middle East, during 1915, as part of what was called the Egyptian Expeditionary Force (EEF). The EEF subsequently went on to wrest control of much of the Middle East from

its Ottoman Turkish overlords. The Turks were key allies of the Germans and consequently, the Middle East became an important theatre of operations for Britain and its allies during the First World War.

The Staffordshire Yeomanry fought with considerable distinction in many of the major battles of the British-led campaign through the Sinai Peninsula, Palestine and Syria. It participated in all three battles around Gaza, between March and October 1917, and played a significant role in the Battle of Beersheba on 6 November 1917, when the allied cavalry turned the Turkish flank and captured Beersheba town and its vital water supplies. Victory at Beersheba allowed the allies to occupy Jerusalem on 9 December 1917. From Jerusalem, British-led forces moved northwards to attack Syria during 1918. At this stage some other yeomanry forces were sent back to Europe to fight on the Western Front. The Staffordshire Yeomanry, however, stayed in the Middle

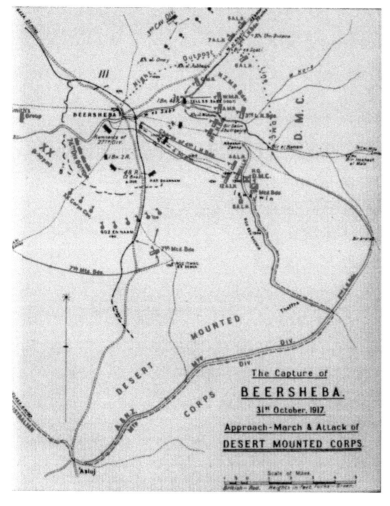

Official 1930 British government map of the Battle of Beersheba.

East and moved into Syria with the rest of General Allenby's invading forces. During September 1918, it made a valuable contribution to the surprise cavalry attacks that led to British victory at the Battle of Megiddo. The regiment also joined the legendary Desert Mounted Corps, commanded by the Australian Harry Chauvel. As the British advanced towards Damascus, in the immediate aftermath of Megiddo, the corps undertook an epic advance through the desert (which covered 87 miles in 33 hours) and captured nearly 6,000 prisoners. This lightning cavalry advance helped bring about the collapse of Turkish resistance in and around Damascus, and the Syrian capital fell to the allies on 1 October 1918. The fall of Damascus, however, brought about little respite for the men of the Staffordshire Yeomanry, and the rest of the Desert Mounted Corps, who were ordered to advance and capture the ancient city of Aleppo, which lay 200 miles to the north of Damascus. By this time the ranks of the Staffordshire Yeomanry had been thinned out considerably by battle casualties and disease: hundreds of men had fallen victim to malignant malaria in the Transjordan Valley, leaving just seventy-five yeomen fit enough to participate in the advance on Aleppo. Nevertheless, the advance continued, and the Turks in the city surrendered on 25 October 1918. Five days later, Turkey surrendered to Britain and its allies, and the war in the Middle East was over.

During the early days of the Second World War, in January 1940, the Staffordshire Yeomanry again found itself in Palestine (as part of the 6th Cavalry Brigade) assisting police in keeping order among the Arab and Jewish communities of the area. The regiment retained its horses until 1941, when it became part of the Royal Armoured Corps and converted to tanks. At the end of November 1941, the Staffordshire Yeomanry became part of the 7th Armoured Division – the legendary Desert Rats – and subsequently fought with this illustrious division during a thousand miles of campaigning, as they pushed Rommel's Afrika Korps westwards from the gates of Cairo all the way to Tunisia. The Staffordshire yeomen fought the Afrika Korps in a series of battles during the course of the North African campaign. In late 1941, it clashed with the Germans in and around the Libyan coastal town of El Agheila, and between 30 August and 3 September 1942 the Staffordshire Yeomanry was part of the British force that fended off Rommel's last great offensive, at the Battle of Alam Halfa, just south of El Alamein. Subsequently, after the great thousand-gun bombardment that presaged the British offensive at El Alamein, on 22 October 1942, it was Staffordshire Yeomanry and 7th Armoured Division tanks (among others) that poured through the gaps created in the German minefields by the earlier infantry assault. After many days of savage fighting, and some horrendous British tank losses, Rommel was forced to retreat, and the Staffordshire Yeomanry, the 7th Armoured Division, and Montgomery's 8th Army as a whole had won a great but costly victory.

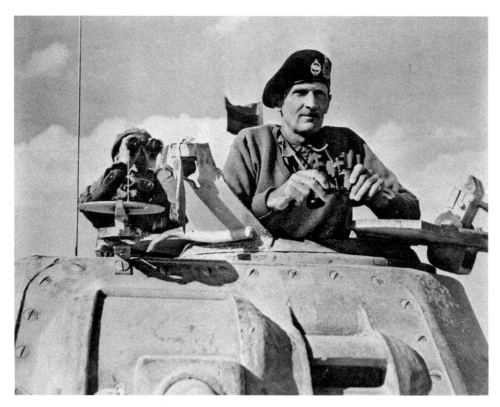

Montgomery supervising Allied tank advance, November 1942. (© National Archives at College Park)

The *Petard* Enigma

Resupplying the Staffordshire Yeomanry, and the 8th Army, as it advanced westwards along the North African coast after El Alamein was a complex logistical problem, made somewhat easier by the bravery of Able Seaman Colin Grazier, from Tamworth, and his colleague First Lieutenant Anthony Fasson, who were both sailors aboard the P-Class destroyer HMS *Petard*. On 30 October 1942, *Petard* clashed with German submarine U571 70 nautical miles north of the Egyptian coast. Grazier and Fasson both drowned, tragically, after successfully retrieving German naval Shark Enigma codebooks from the sinking U-boat, which had been scuttled by its captain. The information gathered by the sailors, at the cost of their lives, proved to be invaluable to Britain's Bletchley Park codebreakers (both Grazier and Fasson were awarded posthumous George Crosses) and naval convoys around the world were rerouted to avoid German submarine attacks. British shipping losses in January and February 1943 were halved, and it became much easier to send supplies to sustain the Staffordshire Yeomanry, and the rest of the 8th Army, during its long advance across the Western Desert.

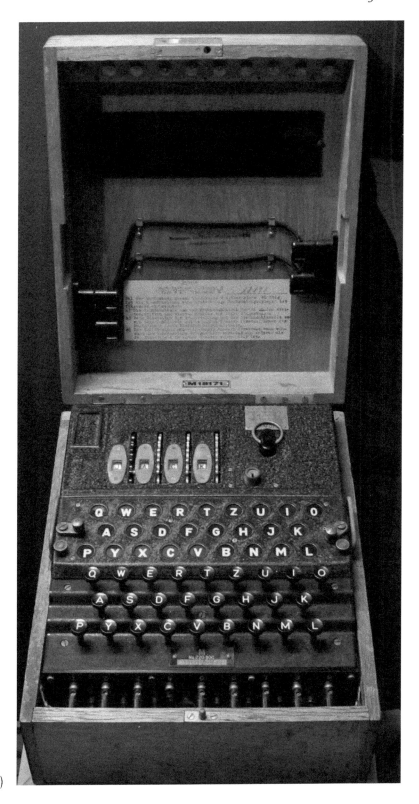

German U-boat
four-rotor enigma
machine, 1942.
(© Brewbook USA)

ADMIRALTY

16th September 1943

MADAM,

 I AM COMMANDED BY MY LORDS COMMISSIONERS
OF THE ADMIRALTY TO INFORM YOU THAT, ON THE ADVICE
OF THE FIRST LORD, THE KING HAS BEEN GRACIOUSLY
PLEASED TO APPROVE THE POSTHUMOUS AWARD OF THE
GEORGE CROSS TO YOUR HUSBAND, ABLE SEAMAN COLIN
GRAZIER, FOR HIS OUTSTANDING BRAVERY AND
STEADFAST DEVOTION TO DUTY IN THE FACE OF GREAT
DANGER, WHILE SERVING IN HMS PETARD, IN A MOST
SKILFUL AND SUCCESSFUL HUNT OF AN ENEMY SUBMARINE
IN MEDITERRANEAN WATERS.

 I AM EXPRESS THEIR LORDSHIPS' PLEASURE
AT THIS MARK OF HIS MAJESTY'S HIGH APPRECIATION,
AND THEIR DEEP REGRET THAT YOUR HUSBAND DID NOT
LIVE TO RECEIVE IT.

 I AM MADAM

 YOUR OBEDIENT SERVANT

 H.V.MARKHAM.

MRS. OLIVE M. GRAZIER
211 TAMWORTH ROAD,
KINGSBURY,
TAMWORTH.
STAFFS.

Admiralty telegram to Mrs Grazier. (Courtesy of Stephen Dickson)

After their exploits in the Western Desert, the Staffordshire Yeomanry was transferred back to England, where they became part of the 27th Armoured Brigade. On D-Day, 6 June 1944, the Staffordshire Yeomanry's Sherman tanks came ashore at Sword Beach, and the tank crews fought their way through the difficult Normandy countryside for the next month, until the 27th's heavy losses forced commanders to pull the brigade back to England during July 1944. During the bloody battles for Normandy, the Staffordshire Yeomanry was one of only a few tank units not to be equipped with either flails (which allowed movement through minefields) or Direct Duplex flotation screens, which allowed heavy tanks to float and move through water. Following the brigade's withdrawal from Normandy some refitting took place, and B Squadron tanks of the Staffordshire Yeomanry later made use of flotation screens to support troops from the 52nd Lowland Scottish Division during their assaults on the waterlogged South Beveland, in the Netherlands, during October and early November 1944. Staffordshire Yeomanry tank crews again used flotation screens in order to assault German positions across the River Rhine, in March 1945.

5. The North and South Staffordshire Regiments

When the 64th and 98th Foot regiments were merged to form the new North Staffordshire Regiment (NSR) in 1881, the new formation's numbers were also added to by local militia and rifle volunteer units. It was, however, the men of the former 64th and 98th Foot who made up the core of the new two-battalion NSR. The 1st and 2nd battalions of the new regiment spent much of the late nineteenth century on garrison duties in various parts of the vast and expanding British Empire, though the 2nd Battalion was the first to see action when it fought the Balochi tribesmen of north-western India during 1884. During the 1890s both battalions were involved in military campaigns in Africa. The first battalion formed part of Horatio Kitchener's Anglo-Egyptian army, which attempted to finally crush the fundamentalist regime of the Dervishes in the Sudan. The North Staffordshire's were involved in the little-known two-day Battle of Hafir in September 1896, when the Dervish armies of Emir Osman Azraq tried unsuccessfully to block British progress across the Hafir cataract on the River Nile.

The North Staffordshire's second battalion was involved in Britain's struggle against the Boers in southern Africa. The battalion only really played a peripheral role in the Boer War, though its men helped garrison Johannesburg, and participated in the destruction of Boer farms and crops in the Eastern

NSR officers at Multan, India, 1908.

Transvaal. Probably the battalion's most significant military contribution to Britain's ultimate victory against the Boers lay in its provision of a separate mounted infantry company, which played a key role in bringing about the defeat and surrender of Boer forces under Koos de la Rey. Garrison duties followed for both regular battalions until the outbreak of the First World War in 1914. During the course of the war, the NSR grew massively in size to encompass eighteen battalions (a typical battalion might contain up to 1,000 men) and these battalions fought in virtually every campaign of significance between 1914 and 1918, on the Western Front, in the Middle East, at Gallipoli, and in northern Italy. At the same time, the borders of the British Empire still needed to be maintained, and the NSR's 2nd Battalion spent the entire war period (and beyond) on active service in India, fighting warring tribesmen on the violent North-West Frontier. The 2nd, together with all the other battalions that saw active service in one theatre or another between 1914 and 1918, earned the NSR a total of fifty-two battle honours, and four Victoria Crosses. The history of the NSR's 1st Battalion during the First World War was very different from that of the 2nd Battalion. From the very start of the conflict in 1914, until the November Armistice of 1918, the 1st Battalion fought on the Western Front. It participated in the First Battle of Ypres, during autumn 1914, and was subsequently involved in the famous Christmas Truce of December 1914, when British troops – much to the consternation of many commanding officers – left their trenches to fraternise with German soldiers and exchange Christmas gifts and best wishes. Subsequently, in March 1915, the battalion was also involved in the failed British attacks at Neuve Chapelle, in the Artois region of France.

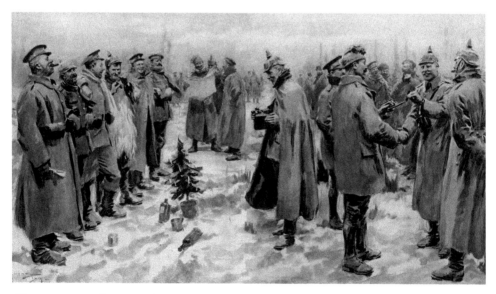

Christmas Truce, by A. Michael. (*Illustrated London News*, 1914)

Right: NSR field officer (full dress), 1914. (© ASK Brown Collection)

Below: 1st Battalion NSR, Cambridge, 1914.

Between April and June 1916, the 1st Battalion suffered terrible losses as a result of German gas attacks in the Messines area. Over 500 men became gas casualties, but despite this, the battalion still managed to participate in Douglas Haig's Somme offensive, launched on 1 July 1916, in which a further 350 NSR casualties were sustained. Heavy casualties continued to be suffered by the 1st Battalion in 1917, during attacks on the Messines Ridge in June, and at the 3rd Battle of Ypres, which began at the end of July. This third British offensive at Ypres, better known as part of the Passchendaele campaign, lasted well into November, and took place over a devastated, rain-soaked sector of the allied front. The NSR's 1st Battalion lost half of its total strength during this nightmare struggle. During the last year of the war, in March 1918, the same battalion faced the might of the German Spring Offensive, near St Quentin, and was virtually wiped out as a result. The battalion needed to be reformed from scratch with new men, and wasn't back in action on the Western Front until the closing days of the war in October 1918, when it lost another 200 men, killed and wounded, during the hard-fought Battle of the Selle.

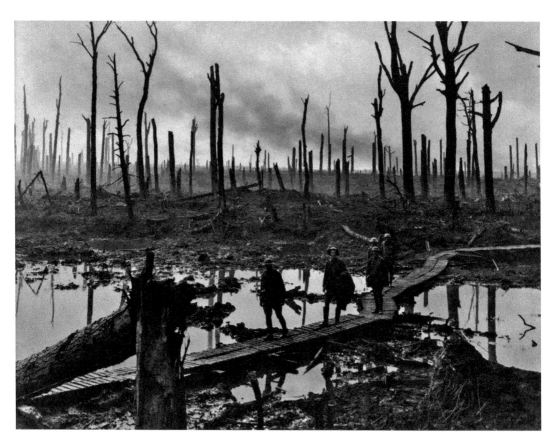

Passchendaele, by Frank Hurley, 1917.

The regulars of the 1st and 2nd battalions were certainly outnumbered by the volunteers (and later the conscripts) who made up the NSR's extra 'service' battalions, which were raised exclusively to fight during the period of the First World War, and then stood down in peacetime. The NSR's 7th Service Battalion had a particularly distinguished wartime record. In 1915, it was sent to fight in south-eastern Europe as part of the huge allied force that intended to seize the Gallipoli Peninsula from the Turks and, thereby, open up supply routes to the Russians via the Dardanelles Straits. Sadly, the campaign was flawed in its execution from the very beginning. Some of the British and allied generals involved were plainly not up to the job of leading such a complex land and sea operation, and by the end of 1915 the overall commander, Sir Ian Hamilton, had to order a humiliating (but successful) final withdrawal of all allied troops from the Gallipoli Peninsula. During the campaign, the NSR's 7th service battalion suffered nearly 500 casualties, made three seaborne landings against the Turks, and formed part of the rearguard, which allowed other British and allied soldiers to be evacuated. Its commanding officer, F. H. Walker, was also killed during the final evacuation.

Lieutenant-Colonel Frank Hercules Walker.

The NSR's 6th (Territorial) Battalion was also in the thick of the action on the Western Front, and one of its stretcher bearers, Lance Corporal William Harold Coltman, from Rangemore near Burton-on-Trent, had the distinction of being the most decorated 'other ranks' soldier in the entire British Army during the First World War. Between 1916 and 1918, Coltman saved the lives of countless wounded men, who he carried away from the battlefield, under fire, and with little thought for his own personal safety. Coltman was a deeply religious man, a former Sunday school teacher, and a member of the Plymouth Brethren evangelical movement. He won the Military Medal twice, the Distinguished Conduct Medal twice, and was mentioned in dispatches. Moreover, in October 1918, during the bloody Battle of Ramicourt, he was awarded the VC for carrying wounded comrades back to safety, on his own, through a hail of German shells and machine gun fire on three separate occasions. The Burton pacifist never fired his rifle in anger during this whole period, but (as his VC citation indicates) his bravery under fire was a source of awe and inspiration to all those who witnessed it.

William Coltman, 1918.

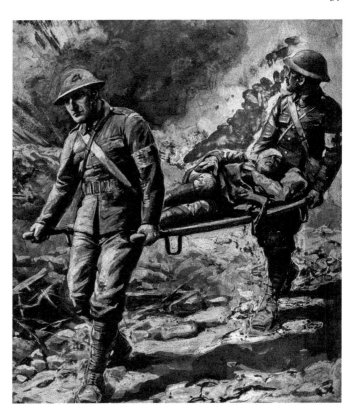

Stretcher bearers, 1916.
(© Wellcome Collection)

At the onset of the Second World War, in September 1939, the NSR possessed two regular battalions of soldiers and two territorial battalions. The war brought about a modest expansion in numbers, with two extra battalions being created (the 8th and 9th). The 6th (Territorial) Battalion landed in Normandy on D-Day, 6 June 1944, and subsequently fought in the bloody and protracted struggles for control of Caen. Its life as a separate entity ended shortly afterwards, however, when the battalion was broken up in order to supply infantry replacements for other severely depleted frontline units. The 7th Territorial Battalion spent the years between 1943 and 1945 in the Orkneys and Shetland before being prepared for service in the Far East.

As a whole, the NSR earned itself twenty-two battle honours during the course of the Second World War, and the regular 1st and 2nd battalions were responsible for many of these military distinctions. The 1st Battalion, which spent the entire period between 1914 and 1918 in Europe, was based entirely in India and the Far East during the Second World War. One company fought against the Japanese on the Andaman Islands during 1942, and in 1943 the entire battalion spent six months fighting in Burma as part of the 36th Indian Infantry Brigade. After this, however, the battalion was used for internal security duties within India, trying to keep a lid on the rising tide of nationalism sweeping across the country.

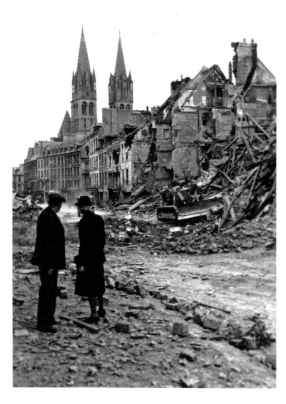

The ruins of Caen, July 1944.

By contrast, the NSR's 2nd Battalion began its Second World War service struggling against the German blitzkrieg across Belgium and France in April and May 1940, before it was evacuated from Dunkirk on 1 June. The battalion remained on home service until 1943, when it was despatched to Tunisia as part of the British First Army to help bring about the final destruction and surrender of Rommel's desert Axis forces. Subsequently, the battalion was involved in the long and often brutal Italian campaign against Kesselring's very effective German forces. The NSR's 2nd Battalion was one of the leading units involved in the Anzio landings of January 1944 and suffered very heavy casualties as a consequence. On 7 February 1944, as part of the breakout from Anzio, the 2nd captured Buonriposo Ridge from the Germans, which they held despite suffering 323 casualties. The position had to be surrendered, however, when the Staffordshire men ran out of ammunition. The bloodletting continued at a considerable pace, so that by the time the battalion was involved in the fourth battle for Monte Cassino in May 1944, it had received eight drafts of replacements to make up for its heavy casualties. Despite these terrible losses the Staffordshire men continued to slog up the Italian peninsula until January 1945, when they were pulled out of the fray and sent to police the situation in the increasingly tense British-mandated territory of Palestine. Once the war had ended the seemingly inexorable process

of army mergers was resumed. The NSR's 1st and 2nd battalions were merged in Egypt in 1948, and the new single battalion regiment remained in the Suez Canal zone until 1950. Between 1950 and 1953 the NSR was back in the UK before it was posted to Korea (under UN control) to act as a garrison force monitoring the recently agreed armistice, which ended the Korean War. Garrison duty in Hong Kong followed between 1954 and 1956 before the NSR ended its seventy-eight-year history as an independent regiment by merging with the South Staffordshire Regiment, to form the Staffordshire Regiment in 1959.

The South Staffordshire Regiment

The 1st and 2nd battalions of the new South Staffordshire Regiment (SSR) – formed in 1881 – were mostly made up of men inherited from the 38th and 80th Foot. As with the NSR, however, men also joined from the various militia and volunteer units present in the area. In 1882, the 1st Battalion was sent to Alexandria, in Egypt, as Britain sought to assert its military and political control over the vital Nile and Suez Canal regions. In 1885, the battalion joined the British Army sent from Egypt into the Sudan to try and rescue General Gordon and relieve the city of Khartoum, which was being besieged by Dervish forces under the Mahdi, Muhammed Ahmed.

Print of Gordon's death at Khartoum, 1885, by Leon Ferris (1863–1930).

The British forces that moved southwards towards Khartoum were commanded by Major-General Garnet Wolseley who, though born in Ireland, had been an ensign in the 80th Foot and was descended from an ancient landed family based at Wolseley Hall, near Rugeley in Staffordshire. Wolseley's expedition to save Gordon and Khartoum failed when the city was sacked and its garrison slaughtered, in January 1885. Even so, the SSR's 1st Battalion played a major part in the British Nile Column, which clashed with a 9,000-strong Dervish army at the Battle of Kirbekan on 10 February 1885. The British forces, led by General William Earle, stormed the heights of Kirbekan, with the South Staffordshire men leading an outflanking movement against the Dervishes. Earle's men won a convincing victory, though at the cost of sixty men killed. Lieutenant-Colonel Philip Eyre, who rose through the ranks from being a private soldier to commanding the SSR's 1st Battalion at Kirbekan, was killed, and the overall British commander, William Earle, was also shot dead during the last moments of the battle.

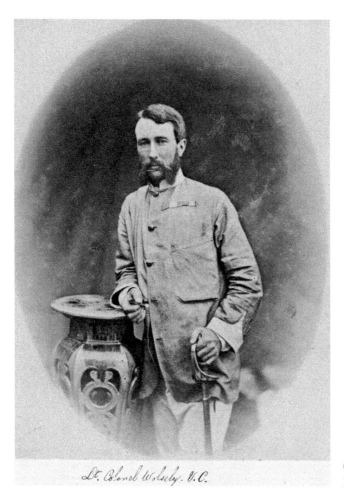

Lt. Colonel Wolseley. V.C.

Garnet Wolseley, by Felice Beato, 1859.

Wolseley Hall, from Morris's county seats, 1879.

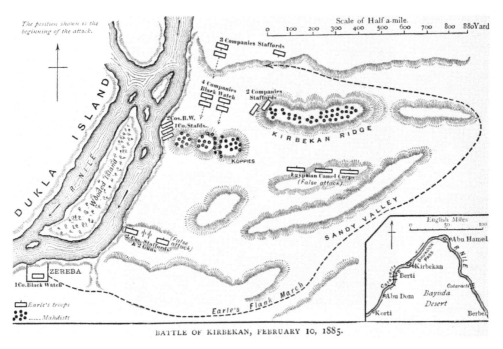

Map of Battle of Kirbekan. (Forbes & Griffiths, 1895)

At least three South Staffordshire battalions were also involved in the struggle against the Boers in South Africa between 1900 and 1902 – the 1st, 3rd and 4th (Militia) battalions. Though these battalions were involved in some sporadic fighting, infection and disease proved to be the main cause of fatalities. The SSR's contribution to the Boer War was dwarfed by its involvement in the First World War, when eight battalions were involved, at one stage or another, in the blood-soaked campaigns on the Western Front. Regimental battalions were involved in most of the major battles, including Mons in 1914, Loos in 1915, and the campaigns on the Somme and at Passchendaele in 1916 and 1917. In September 1918, companies of the 5th and 6th battalions were also involved in assaulting the German defensive Hindenburg Line, near the St Quentin Canal. In addition to fighting on the Western Front, the 2nd companies of the 5th and 6th battalions were involved in suppressing the Easter Rising in Dublin during 1916, and the 7th (Service) Battalion fought in the Gallipoli campaign between August and December 1915. The 2nd and 9th battalions were also despatched to fight on the lesser-known Italian Front. Italy became a British ally in 1915 and fought the Austrians and Germans in the mountainous Italian Alpine region. In winter 1917, British and French forces were rushed to the region in order to prevent a complete Italian military collapse, and the SSR battalions bolstered a section of the Italian Front that ran from the Alps down towards Venice.

SSR cap badge, 1914–18. (Courtesy of Gunther Lux)

SSR Tyne Cot First World War memorial,
Belgium. (Courtesy of BsOu1OeO1)

The SSR's record of service during the First World War was certainly impressive. It was, however, during the Second World War that the regiment really achieved martial immortality as a result of its involvement in some of the most stirring and desperate military campaigns of all time. The regiment's 2nd Battalion was converted to a glider infantry role in 1941 and became part of the legendary British 1st Airborne Division. In 1943, it suffered heavy casualties during glider landings at Syracuse in Sicily, and in September 1944 it played a prominent role in the doomed Operation Market Garden, when Britain and its allies attempted a narrow thrust across the bridges of the Netherlands into the industrial heartlands of Germany, all with the aim of ending the war by Christmas. Ultimately, Market Garden's success depended upon seizing the bridge over the Rhine at Arnhem. The South Staffordshire's landed with the rest of the 1st Airborne Division in drop zones in the Wolfheze and Oosterbeek areas. The lightly armed airborne troops met unexpectedly heavy resistance from German panzer divisions refitting in the area, and reinforcements from the British XXXth Corps failed to reach Arnhem. Nevertheless, 1st Airborne fought on during days of heavy fighting, and Robert Cain and John 'Jack' Baskeyfield (both men were from the South Staffordshire's 2nd Battalion) were awarded VCs for their actions during this period.

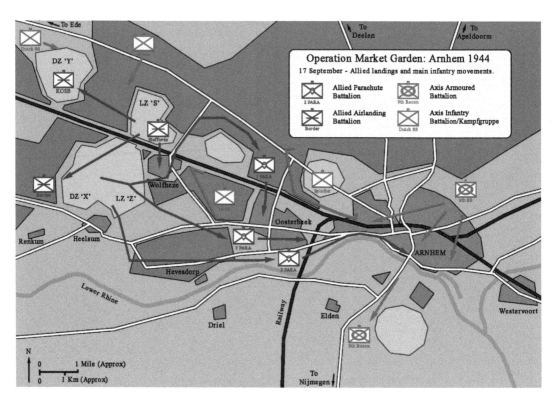

Above: Arnhem campaign map.
(Courtesy of Ranger Steve)

Left: Memorial glider at Wolfheze
landing grounds, Netherlands.

Major Cain (born in China but raised in the Isle of Man) advanced with his South Staffordshire men as far as the St Elizabeth's Hospital in Arnhem, but then led a fighting retreat back to Oosterbeek, where he and his men fought on for days and Cain destroyed a number of enemy tanks, on his own, with the aid of an anti-tank Piat gun. He survived the campaign, despite receiving some severe injuries, and collected his VC in person from King George VI. Cain's daughter, Frances, later married TV personality Jeremy Clarkson. Like many of his generation, Cain was modest about his achievements, and Clarkson recalled that his father-in-law had told him nothing at all about his epic role in the desperate fighting at Arnhem.

Lance-Sergeant Baskeyfield, a former butcher from Burslem, was less fortunate than Cain, and died at his post, on the southernmost road between Oosterbeek and Arnhem, where he led a team manning two six-pounder anti-tank guns. Baskeyfield and his men died while fending off armoured assaults from the Panzer divisions in the area. Every man under his command became a casualty, and Baskeyfield himself was badly injured. Despite this, he refused to be evacuated and continued – on his own – to resist the German assault, until he was killed. The Stoke man's remains were never recovered, but his name is recorded on the Memorial to the Missing at nearby Groesbeek CWGC Cemetery. Arnhem was the only occasion during the entire Second World War when men from a single British battalion received two separate VCs for their conduct during the same battle. The cost of Arnhem proved to be a heavy one. Only 2,000 men, out of an original force of 10,000, were able to retreat across the Rhine, and the 1st Airborne Division was effectively destroyed as a viable fighting force.

Robert Cain VC, December 1944.

Left: John 'Jack' Baskeyfield
statue, Stoke. (Courtesy of
Steve Birks)

Below: The former St Elizabeth's
Hospital, Arnhem.

Oosterbeek-Arnhem CWGC Cemetery, Netherlands.

Memorial cross at Oosterbeek-Arnhem CWGC Cemetery, Netherlands.

On the other side of the world, in Burma, the South Staffordshire's 1st Battalion fought against the Japanese as part of the maverick British general Orde Wingate's legendary Chindits force. The Chindits were officially known as Long Range Penetration Groups, and they specialised in attacking Japanese troops and communications, deep behind enemy lines, in the dense Burmese jungles. The Chindits were really the first British force to go on the offensive against the Japanese, and their efforts and sacrifices were immense. In March 1944, Lieutenant George Cairns, a South Staffordshire Chindit, was eventually awarded the VC for his actions during hand-to-hand fighting with Japanese soldiers at the White City landing grounds in Burma. Cairns' left arm was severed by a Japanese sword thrust during these struggles, but he kept on fighting, and the enemy were repulsed. The SSR officer died the following day from his wounds. Sadly, all the documentation recommending Cairns for the VC was lost in the March 1944 plane crash which killed General Wingate, and it wasn't until 1949 that Cairns' widow finally collected her husband's posthumous award.

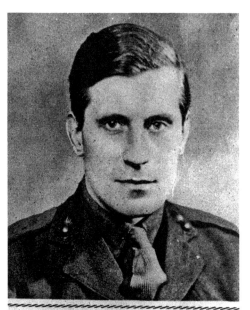

MAJOR-GENERAL O. C. WINGATE.
In command of the airborne troops who have landed behind the Japanese lines in Burma and of the columns who have crossed the Chindwin is Major-General Wingate. His qualities as a leader were proved in Palestine, the Middle East and Abyssinia, not to mention his expedition into the heart of Burma last year.

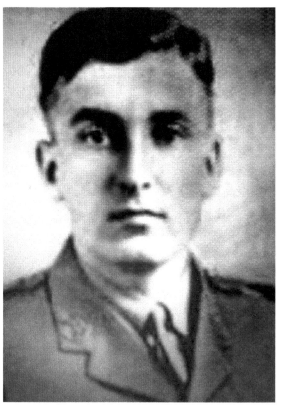

Above left: Orde Wingate. (© National Photo Collection of Israel)

Above right: George Cairns, 1944. (© IWM Collections)

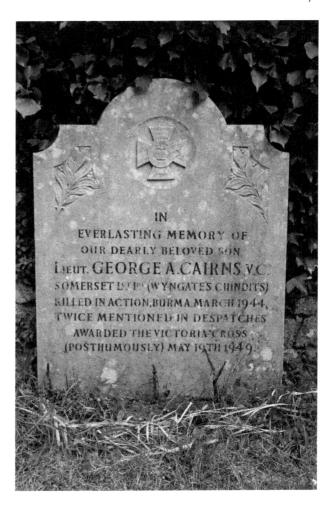

George Cairns
memorial headstone.
(Courtesy of Barfbagger)

Other units of the SSR – in addition to the 1st and 2nd battalions – also provided exemplary service during the period of the Second World War. The 5th and 7th battalions, together with two companies of the 6th, were merged with battalions of the NSR in order to create the 59th (Staffordshire) Infantry Division. This division was sent to France to fight in the battles for Caen, which lasted between June and August 1944. The city was a vital communications hub, which the Germans were desperate to retain, and in the battles for the city, the 59th proved themselves to be one of the very best units in the entire 21st Army Group (at least according to Field Marshall Montgomery). Heavy casualties within the 59th, however, meant that the division was broken up in August 1944 and its men were used as replacements for losses in other infantry divisions. Following its wartime exploits the SSR was reduced to one battalion in 1948, and garrison postings in Hong Kong, Northern Ireland, Cyprus and Germany followed, before the merger with the North Staffordshire's finally took place in January 1959.

6. Aces, Bases and Spitfires

Regimental and military aviation history in Staffordshire certainly overlaps during the period of the First World War. The Royal Flying Corps (RFC) was, to begin with, simply a branch of the army. Thus, many of its early recruits were seconded from various army regiments in order to become either pilots or observers in the RFC. Alan Jerrard, born in Lewisham in 1897, was just such a seconded pilot. He grew up in Sutton Coldfield in the West Midlands, and was commissioned as an officer in the South Staffordshire Regiment before transferring to the RFC as a pilot in 1916. From mid-1917 onwards, he served on the Western Front with 19 Squadron, and then with 66 Squadron, and proved himself to be a fighter ace of considerable skill. Between February and March 1918, Jerrard was based in Italy, where he shot down three enemy aircraft and one enemy observation balloon. In addition, he also took part in an offensive patrol with two other RFC planes in which he shot down one Austrian aeroplane, then launched a solitary attack on Austrian planes landing and taking off from an enemy airfield. Jerrard caused absolute mayhem at the airfield in his Sopwith Camel fighter biplane and only paused his attack in order to assist another RFC plane in difficulties, shooting down one more enemy plane in a rapid but deadly dogfight. Jerrard then resumed his low-level attack on the Austrian airfield, flying at little more than 50 ft above ground level, and only ceased his attack when ordered to return to base by his commanding officer – the former South Staffordshire Regiment officer was later awarded a VC for these actions.

Sopwith Camel, RAF Museum. (Courtesy of Oxyman)

Later in 1918, Jerrard was shot down over enemy territory and became a prisoner of war (POW). He escaped from captivity during the last days of the war and was able to rejoin the allied lines. Although most men returned home once the First World War was over, Jerrard went on to serve in Russia during 1919 as a flight lieutenant, where he became part of the abortive Western military campaign to remove the Bolsheviks from power. After returning from Russia, Jerrard went on to enjoy a long career in the Royal Air Force (which was created from the merger of the RFC and the Royal Naval Air Service in April 1918). He retired from the RAF due to ill health in 1933 and eventually passed away in Lyme Regis, Dorset, in 1968. His ashes were interred with the remains of his wife, at Hillingdon Churchyard, and his VC remains on display at the Imperial War Museum in London.

Staffordshire produced fighter pilots of particular distinction during the Second World War. George Bennions was born in Stoke-on-Trent in 1913, and in 1929 he joined the RAF as an apprentice fitter at the service's technical school, based at RAF Halton in Hertfordshire. Three years later, in 1932, he successfully qualified as an RAF engine fitter. Many Halton trained ground crew members had dreams of becoming flyers, but few actually made the transition – George Bennions was one of the few, becoming a sergeant-pilot with 41 Squadron in 1936 and receiving his commission as an officer with the same squadron in April 1940. Bennions himself claimed his success in rising from engine fitter to fighter pilot was due to his prowess as a boxer. Senior RAF officers preferred men who were good at sport, and Bennions' boxing abilities certainly helped promote his career. At the beginning of his flying career with 41 Squadron, in Aden, Bennions flew

Alan Jerrard VC, *c.* 1918.

semi-obsolete Hawker Demon fighters. However, by 1940 41 Squadron was back in England and Bennions was flying the new Supermarine Spitfire fighter plane. During the Battle of Britain, the squadron was based at RAF Hornchurch in Essex. During intense fighting in July, George Bennions shot down his first Messerschmitt 109 fighter plane. He shot down another German plane on the following day and was himself forced into a crash landing in Kent after his Spitfire was damaged in a dogfight. During a supposed rest break with his squadron at RAF Catterick, in North Yorkshire, the Stoke pilot was again involved in an epic aerial battle with over 140 German bombers and fighters along the Yorkshire coast. By 9 September 1940, George Bennions was a much esteemed and respected Spitfire fighter ace, with at least twelve 'kills' accredited to his name, and on 1 October 1940, he was awarded the Distinguished Flying Cross (DFC).

Bennions was, however, far more than just a supremely effective fighter ace. He seems to have shown genuine compassion for those he fought against in the skies and later went on record to express his relief when the occupants of planes he shot down were able to bail out. The Spitfire ace also helped save the lives of newly trained RAF pilots. Flying at night was difficult even for experienced pilots like Bennions, but for new pilots night flying was often a death trap. After one pilot from Catterick flew into a house during a night operation, Bennions suggested to senior RAF commanders that new pilots should only fly at night in conditions of full moonlight. Initially, one senior RAF officer seems to have accused Bennions of being 'scared' of night flying (not a sensible move with an accomplished boxer) but eventually the Stoke pilot's suggestions were accepted, and new pilots acclimatised to night operations by only flying in conditions of full moonlight. George Bennions fought throughout the Battle of Britain. In early October 1940, just before he was due to go on leave to celebrate his DFC, Bennions engaged in one last dogfight.

Supermarine Spitfire X4560. (Courtesy of Alan Wilson)

He and his 41 Squadron colleagues at Hornchurch dived into a group of over 100 German raiders, and Bennions intended to bring down the rear most plane in the enemy formation. He shot down this plane, but as he was doing so a German cannon shell exploded in his cockpit. Bennions was blinded in his left eye and sustained severe injuries to his right arm and leg. His cockpit was also ablaze, and the severely burned pilot struggled to bail out of his stricken Spitfire. Eventually, as his plane plunged towards the ground, Bennions was able to undo the left section of his cockpit screen, bail out, and pull the release cord of his parachute. He was later found in a field, unconscious, near Hatfield in Hertfordshire, and taken to hospital. The terrible injuries he received in this last dogfight were treated at the Queen Victoria Hospital in East Grinstead, where he became an early patient of the world-renowned plastic surgeon Sir Archibald McIndoe.

For an initial period Bennions seems to have suffered from severe depression, which ended when the Stoke man was introduced to some of McIndoe's other RAF patients, who had far more serious injuries and burns. Thereafter, George Bennions return to health and vitality was spectacular. He returned to the wartime RAF in 1943, though not in actual combat roles, as a promoted squadron leader in North Africa and then as a fighter controller at various RAF stations in northern England. He received the honour of being mentioned in dispatches for his endeavours and during a secondment in Corsica he received shrapnel wounds, which needed the further medical attentions of Archibald McIndoe. George Bennions finally left the RAF in 1946 and retrained as a woodwork/metalwork teacher. He became a talented silversmith, with his own hallmark, and was also an enthusiastic golfer and sailor. The former fighter pilot from Stoke-on-Trent finally passed away at the age of ninety, in 2004, having led a long and very impressive life of service, sacrifice and dedication.

Archibald McIndoe at East Grinstead Hospital, by Anna Katrina Zinkeiser, 1944.

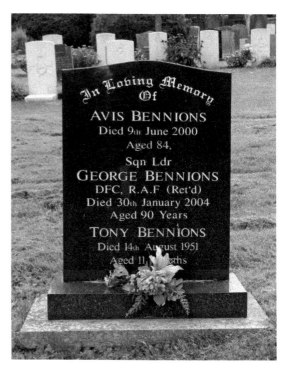

Above left: George Bennions in 2001. (Courtesy of Tatooine721)

Above right: George Bennions' memorial headstone. (Courtesy of Berkeley)

Reginald Mitchell and the Spitfire

George Bennions loved flying, and he loved flying the Spitfire fighter plane designed by Reginald Mitchell. Both men had a great deal in common. Bennions was born at Burslem, in Stoke-on-Trent, and Mitchell was born just a few miles away at Victoria Cottage, in Talke Pitts, in 1895. Mitchell and Bennions also went to Hanley High School, though at different times, and both men pursued careers in engineering, with Bennions beginning his RAF career as an engine fitter, while Mitchell began his working life as an apprentice at the Kerr Stuart locomotive works in Stoke. Other employees at Kerr Stuart soon observed that the new apprentice had a quiet, contemplative nature, combined with a restless curiosity, and a constant desire for self-improvement. In 1917, he joined the Supermarine Aviation Company in Southampton, and by 1919 he was the company's Chief Designer. In 1920, at the age of twenty-five, he was also appointed as Supermarine's Chief Engineer, and by 1927 he was the company's Technical Director.

Mitchell's brilliance as an aircraft designer was recognised very quickly by Supermarine's competitors. When the massive national Vickers company took over Supermarine in 1928, they did so on the understanding that Mitchell and

Unusual slate statue of Reginald Mitchell.
(Courtesy of Paul Hudson)

his design team stayed in place for at least the next five years. Mitchell was as good as his word and stayed at Supermarine for the rest of his career (a career and life tragically cut short by cancer in 1937). Although Mitchell's name will be forever linked to the Spitfire, between 1920 and 1936 he designed twenty-four other aircraft, predominantly seaplanes, but also including fighters and bomber planes. At the time of his death in 1937, before the first Spitfires had actually rolled off the production lines, Mitchell even had plans to design a revolutionary new type of bomber. The evolution of Mitchell's Spitfire concept was a long and complex one, generally thought to have begun with the seaplanes entered by Supermarine for the international Schneider Trophy airspeed races. Mitchell designed Supermarine planes won the event in 1927, 1929 and 1931. The 1931 victory allowed Britain and Supermarine to keep the Schneider Trophy in perpetuity, and the open cockpit, gull-winged seaplane which won the 1931 race bore many similarities to the prototype Spitfire Mitchell and Supermarine produced in response to the Air Ministry's 1930 specification F.7/30 requesting designs for a new monoplane British fighter.

Over the following few years Mitchell battled increasing ill health (he had a lung operation in 1933) in order to revise his design. The gull wings went and were replaced by the thin elliptical wings, which were years ahead of their time and helped give the fighter plane its aesthetically pleasing final shape. The initial Goshawk engine was also replaced by the iconic Rolls-Royce Merlin engine, and

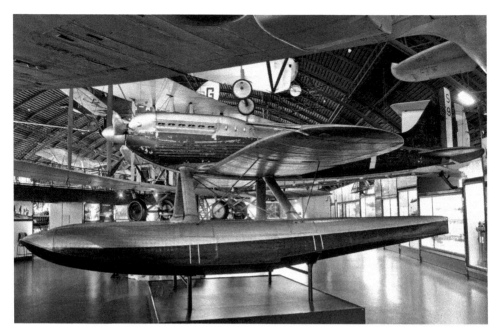

Supermarine seaplane S.6B, 1931 Schneider Trophy winner. (Courtesy of Alan Wilson)

the plane that the dying Mitchell watched during its test flights in 1936 – parked in his old Rolls-Royce by the Eastleigh airfield hangars – was very different from the one envisaged in the original prototype. The initial Air Ministry order was only for 310 of these new aircraft, and at the time of the Battle of Britain RAF Hurricane fighter aircraft still outnumbered Spitfires. Nevertheless, the Mitchell designed fighter was more than a match for anything that the German Luftwaffe could throw at it. Reginald Mitchell was undoubtedly proud of his new design, though perhaps not so keen on its name. The name 'Spitfire' (originally given only to the prototype) was given to the whole class of new fighters at the suggestion of Sir Robert McLean, chairman of Vickers-Armstrong. When Mitchell found out, his only comment was to say, 'Just the sort of bloody silly name they would choose.'

The Spitfire at war was a magnificent machine, with some weaknesses, but no deep-seated flaws. Its armaments, for example, didn't have the firepower of the combined cannons and machine guns carried by the Messerschmitt 109s. The Spitfire's long nose also made visibility when taxiing very limited indeed. Even so, countless RAF pilots adored the Spitfire, and most found it easy to fly, with very responsive controls. Reginald Mitchell left a fine and enduring legacy behind him, and it was a legacy recognised even by the enemy. When Herman Goering asked his Luftwaffe commanders what they needed in order to destroy the RAF in 1940, the German fighter ace Adolph Galland replied with the often misquoted comment 'an outfit of Spitfires'.

Above left: Reginald Mitchell statue, Hanley. (Courtesy of John M)

Above right: Reginald Mitchell pub sign, Hanley. (Courtesy of John M)

RAF Bases

In addition to its fighter aces and the Spitfire designer Reginald Mitchell, Staffordshire also possessed some major RAF bases that were of key importance during the First and Second World Wars. RAF Perton was situated just a few miles to the north-west of Wolverhampton, and between 1916 and 1918 it was the home of 38 Squadron, which had been given the responsibility of defending the West Midlands from German Zeppelin and Gotha bomber attacks. For a short period, 38 Squadron fighters based at Perton were headed by Arthur Harris, later the head of RAF Bomber Command during the Second World War. During the Second World War, there were at least twelve RAF stations in operation throughout Staffordshire, in addition to a US Army Airforce base near Stone. A multiplicity of airfields was certainly a necessity, particularly in wartime, when either bad weather or enemy damage might prevent planes from returning to their home base. Thus, many of Staffordshire's wartime RAF bases acted as what were called satellites or Relief Landing Grounds (RLGs) where aircraft from other stations might land whenever it was deemed necessary. RAF Tatenhill, roughly

5 miles west of Burton-on-Trent, was a satellite station for RAF Lichfield and RAF Wheaton Aston. RAF Perton also acted as an RLG for aircraft from a number of neighbouring bases, including those from the major training establishment at Wheaton Aston.

The major function that many of these RAF bases shared in common was the key one of training pilots, navigators, bomb aimers, radio operators and gunners for Bomber Command operations. In addition, glider pilots were trained at RAF Meir, near Stoke-on-Trent, and the Dutch army's Princess Wilhelmina Brigade was trained at RAF Perton. A huge technical training school was also developed at RAF Hednesford, just south of Cannock Chase. Hednesford's huge training camp, which began to function from mid-March 1939 onwards, operated as No. 6 School of Technical Training. The station had no proper airfield, but still managed to accommodate up to 4,000 trainees and 800 staff

RAF Tatenhill gunnery trainer remains. (Courtesy of Mike Searle)

RAF Wheaton Aston watchtower remains. (Courtesy of James Loach)

during the period of the Second World War. RAF aircrew training was carried out via what were called Operational Training Units (OTUs), and these OTUs were dotted around Staffordshire. No. 27 OTU was formed at RAF Lichfield in April 1941, and trained aircrews, mostly from Australia and the Commonwealth, to fly Wellington bombers. Pilots from the Commonwealth were also trained for Bomber Command, using Airspeed Oxford aircraft, at RAF Wheaton Aston. Elsewhere, prospective Wellington and Bristol Blenheim bomber crews were also trained at RAF Hixon, which was situated roughly 7 miles to the east of Stafford. Additionally, RAF Tatenhill (originally known as Crossplains) situated just to the west of Burton-on-Trent, was used to train bomber crews until 1944. Bomber Command air crews were also trained at RAF Meir, near Stoke, RAF Perton, and at OTU's No. 21, 23 and 30, which were based at RAF Seighford, a few miles to the north-west of Stafford.

Life at an OTU could certainly be dangerous. During the course of the Second World War, 8,090 Bomber Command fatalities occurred during training accidents – a staggering statistic illustrating that roughly one in seven of those killed in RAF Bomber Command between 1939 and 1945 actually died before they'd even begun the deadly business of bombing the Axis powers during wartime. Training for night flying, in all conditions, in often poorly serviced and semi-obsolete aircraft, took a fearful toll of new recruits, in Staffordshire and elsewhere. The distinction between operational (combat) missions and training exercises could also be a somewhat blurred one. OTU No. 30, for example, was given the responsibility for Air Sea Rescue missions in January 1944. Planes from

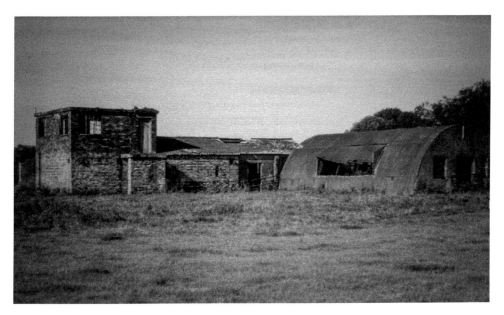

RAF Seighford watchtower remains. (Courtesy of Mike Searle)

RAF Hixon would therefore fly out searching for lost pilots, sailors and other Allied personnel, with OTU instructors in command, but with aircrews composed of trainees. Such rescue missions, though risky, were certainly not as dangerous as the operational bombing missions launched from RAF Lichfield, which was the busiest Staffordshire airfield during the Second World War, and a control point for all wartime aviation traffic passing over the Birmingham area. In May 1942, planes from Lichfield participated in the RAF's 1,000 bomber raid over the German city of Cologne, which burned down 13,010 houses, killed 469 people, and led to roughly one-fifth of the city's 700,000 population fleeing from the area.

During 1943, Lichfield planes carried out bombing missions against German airfields in Occupied Europe, and also participated in what were called 'nickel raids' against German cities. Planes from nearby RAF Hixon often participated in these raids, which were really early forms of psychological warfare, and involved dropping vast numbers of propaganda leaflets on the populace of the larger German cities. The value of such raids is difficult to determine, but they certainly provided bomber crews with invaluable experience of night flying over enemy territory.

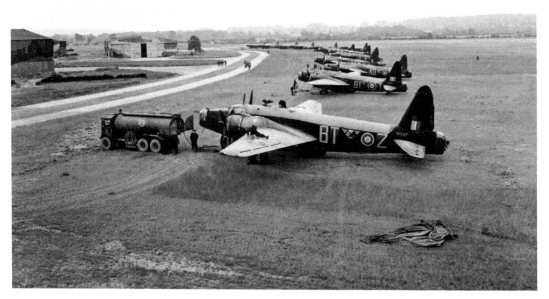

Wellington bombers at RAF Hixon, 1943. (© IWM Collections)

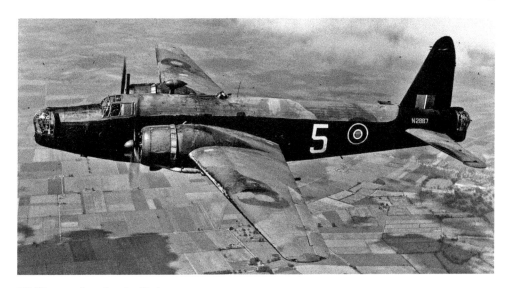

Wellington bomber in flight, 1943.

Maintenance of aircraft was another major function of Staffordshire's RAF bases. No. 51 Maintenance Unit was based at RAF Lichfield from August 1940 onwards and specialised in carrying out modifications to newly built aircraft, which were then sent on to frontline squadrons. Similar Maintenance Units were based at RAF Stafford and at RAF Abbots Bromley. Undoubtedly, the most dangerous work undertaken by Staffordshire's RAF Maintenance Units was the storage and destruction of vast quantities of explosives and ammunition. The Tatenhill base was used by the RAF's School of Explosives (between October 1945 and January 1947) in order to break up vast quantities of surplus ammunition, which was then dumped at sea. No. 21 Maintenance Unit was also responsible for storing substantial amounts of ammunition at RAF Abbots Bromley, and the same unit – under the command of Group Captain Storer – managed the massive underground bomb storage dump at RAF Fauld, near Tutbury. On 27 November 1944, one of the biggest non-nuclear explosions in history occurred at RAF Fauld, when between 3,900 and 4,400 tons of mostly high explosive ordnance was ignited accidently, probably by one of a number of poorly trained Italian POWs working at the installation. The ordnance, which had been stored in old gypsum mine workings nearby, included various shells, bombs and over 500,000,000 rounds of ammunition. Two distinct explosions were heard at the facility, and a mushroom cloud ascended several thousand feet into the air. Debris was scattered over a radius of 1,300 m and a crater was produced which was 230 m in length and 30 m deep. At least seventy people were killed in the disaster, and the dead included RAF personnel, civilians and Italian POWs. A locally organised relief fund made payments to victims and their families until 1959.

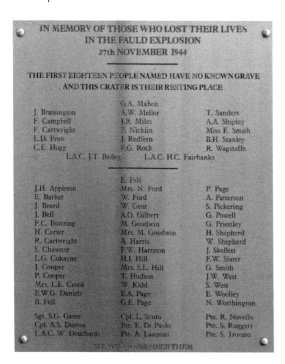

IN MEMORY OF THOSE WHO LOST THEIR LIVES
IN THE FAULD EXPLOSION
27th NOVEMBER 1944

THE FIRST EIGHTEEN PEOPLE NAMED HAVE NO KNOWN GRAVE
AND THIS CRATER IS THEIR RESTING PLACE

	G.A. Mahon	
J. Brassington	A.W. Mellor	T. Sanders
F. Campbell	J.R. Miles	A.A. Shipley
F. Cartwright	F. Nicklin	Miss E. Smith
L.D. Frow	J. Redfern	B.H. Stanley
C.E. Hogg	F.G. Rock	R. Wagstaffe
L.A.C. J.T. Bailey	L.A.C. H.C. Fairbanks	

	E. Fell	
J.H. Appleton	Mrs. N. Ford	P. Page
E. Barker	W. Ford	A. Patterson
J. Beard	W. Gent	S. Pickering
J. Bell	A.O. Gilbert	G. Powell
F.C. Bowring	M. Goodwin	G. Priestley
H. Carter	Mrs. M. Goodwin	H. Shepherd
R. Cartwright	A. Harris	W. Shepherd
S. Chawner	F.W. Harrison	J. Skellett
L.G. Cokayne	H.J. Hill	F.W. Slater
J. Cooper	Mrs. S.L. Hill	G. Smith
P. Cooper	T. Hudson	J.W. West
Mrs. L.E. Crook	W. Kidd	S. West
F.W.G. Daniels	E.A. Page	E. Woolley
B. Fell	G.E. Page	N. Worthington
Sgt. S.G. Game	Cpl. L. Scuto	Pte. R. Novello
Cpl. A.S. Durose	Pte. E. Di Paolo	Pte. S. Ruggeri
L.A.C. W. Deucharas	Pte. A. Lanzoni	Pte. S. Trovato

WE WILL REMEMBER THEM

Close-up of Fauld Crater memorial plaque. (Courtesy of Humphrey Bolton)

Fauld explosion memorial at the National Memorial Arboretum, Alrewas. (Courtesy of Andy Mabbett)

7. Aspects of the Home Front

During the past 300 years or so, military personnel from Staffordshire have been deployed to virtually every part of the world. In many respects, however, it was on the Home Front (during the First and Second World Wars) that the county's martial character was at its most evident. For a start, tens of thousands of Staffordshire men either volunteered for, or were conscripted into, Britain's armed forces during both wars. During the first six months of the First World War, for example, 28,400 Staffordshire men voluntarily enlisted for military service (conscription only began in early 1916). This patriotic fervour for joining up was aided and abetted by the activities of men like Albert Blizzard, owner of a Cheadle brickmaking business, who toured areas such as Halmerend, Knutton and Audley with marching bands and recruitment parades, urging all eligible males to enlist. Enthusiasm for joining up was much less evident at the onset of the Second World War, but the speedy introduction of conscription, even before the war began, still ensured that many thousands of Staffordshire men left the county in order to serve in the army, navy or air force. This exodus of forces-bound men from Staffordshire was more than counterbalanced by the influx of foreign military personnel into the county. During the Second World War in particular, the arrival of armed forces personnel from America, the British Empire and Commonwealth, and from occupied Europe, meant that the military presence in the county was more multi-national and multi-ethnic than ever before. There were Americans concentrated in the Trentham area near Stoke, and at Stone, and large numbers of Commonwealth and empire airmen were training at Staffordshire's many RAF bases. In addition, Dutch soldiers were present in the county, at brigade strength. This wartime military diversity was made even more evident by the presence of large numbers of German POWs, based at camps throughout Staffordshire. During the last year of the First World War, a massive camp became operational at Brocton, near Cannock Chase, which could accommodate up to 6,000 German POWs. The camp was actually situated on land belonging to the Earl of Lichfield, and German prisoners were often employed on various estate management projects at the earl's Shugborough Hall residence. During the Second World War, a range of POW camps were set up to house both German and Italian inmates. Teddesley Hall camp, near Penkridge, was a particularly large establishment used to accommodate German POWs. In December 1944, thirteen Germans escaped from the camp and scattered to various parts of the country. Twelve men were

later recaptured, but one escapee vanished without trace, and nothing was ever heard of him again. Loxley Hall, near Uttoxeter, and Lawn Camp at Codsall were used for Italian POWs. These Italians, along with many of the German POWs in the county, were used for agricultural and rebuilding work, and many stayed on after the end of the war, married local women and became settled members of Staffordshire society. Flaxley Green was an American run transit camp, near Rugeley, which also held Italian POWs. In March 1945, the camp achieved some national notoriety when one of its American guards, Aniceto Martinez, became the last American serviceman to be executed on British soil, when he was found guilty of raping a seventy-two-year-old Rugeley woman (rape was a capital crime under US military law).

In addition to the presence of POWs and able-bodied Allied soldiers in the county, Staffordshire's hospitals also treated many thousands of injured allied service personnel during both world wars. Between 1914 and 1918, a range of civilian hospitals admitted military casualties in Walsall, Wolverhampton, Stoke, Lichfield and Stafford. In addition, specific military hospitals were utilised, such as the 594-bed Cannock Chase Camp, and there were also numerous auxiliary hospitals, annexes and minor hospitals set up at various locations throughout the county. Hospitals could vary in size, from the very small to the large, and some had particular niche specialisms. For example, a major specialist venereal

Loxley Hall. (Courtesy of Stephen Richards)

diseases hospital was set up in annexes to Whittington Barracks at Lichfield, which could accommodate up to fifty officers and 754 men. Ravenhill Red Cross Hospital, at Rugeley, was opened in March 1915 with just twenty beds, though this had increased to thirty-seven beds by the end of August 1917. Ravenhill was run on a financial shoestring by its commandant, Miss Lambert of the 14th Staffordshire Voluntary Aid Detachment, in a house donated by Darea Curzon, Baroness Zouche. Darea also had to donate £50 to Miss Lambert to cover the small hospital's initial running costs. Ravenhill was a great contrast to some of the massive military hospitals set up in Staffordshire, such as Brindley Heath, at Cannock Chase, Burntwood Military Hospital at Rugeley, and Cheddleton Hospital at Leek. Brindley Heath was built in 1916 and had twelve wards and over 1,000 beds. The hospital provided medical support for the nearby Brocton and Rugeley army training camps, as well as accommodating troops wounded on the Western Front. Burntwood and Cheddleton began life as designated Victorian lunatic asylums but went on to provide support to massive numbers of injured service personnel and civilians in both world wars. Cheddleton could accommodate up to 800 patients, while Burntwood had the capacity to deal with roughly 1,300 patients. During summer 1940, Burntwood's nursing staff dealt with 242 injured soldiers evacuated from the beaches of Dunkirk, many of whom were suffering from burns and shrapnel wounds. In addition, civilians injured in the nearby Birmingham blitz were also treated at Burntwood's emergency hospital facilities.

Cheddleton Hospital. (Courtesy of Brian Deegan)

Convalescing American soldiers made a considerable wartime impact in Staffordshire. Small numbers of US service personnel were treated at the Old Manor House Auxiliary Hospital at Tettenhall during the First World War. However, a far larger US medical presence was established during the Second World War when the 312th Station Hospital was built for the US Army at Shugborough Park in 1943. This was a massive 1,000-bed hospital where over 500 nurses, doctors and other medical staff worked under the command of Colonel Ernest Parsons. The hospital developed as a specialist psychiatric unit, assisting service personnel traumatised by battle fatigue and shell shock, known today as PTSD.

Bombs, Bullets and Blitzes

The Staffordshire area was bombed by the Germans on a number of notable occasions during the First and Second World Wars. On 31 January 1916, a group of nine Zeppelins were involved in bombing various parts of eastern England and the Midlands. At least some of these raiding Zeppelins appeared over Staffordshire and discharged their bomb loads in rather random attacks, which mostly targeted (more through accident than design) the towns of Burton-on-Trent and Walsall. Three people were killed in the Walsall attack, including the town's Lady Mayoress, Julia Slater. Aerial navigation was in its infancy during the First World War, and, hampered by high winds and poor visibility, the Zeppelins also succeeded in dropping bombs on the Black Cat Billiard Saloon in High Street, Burton, and on the unfortunate Mr Richards' butcher's shop and abattoir (where a large herd of pigs were killed). More legitimate targets such as Burton's Midlands Railway depot and locomotive sheds were also hit, and according to heavily censored newspaper accounts of the time, a total of thirty people were killed and sixty injured as a result of this one raid over Staffordshire.

Zeppelin L21 returned to bomb industrial targets in Stoke, during late November 1916, but there were no casualties, and the airship was shot down during its return journey to Germany. During the Second World War, both German and British offensive bombing campaigns were far from being precise. The German aerial blitzes over nearby Coventry and Birmingham caused considerable devastation, but Staffordshire was never really attacked on the same scale. Nevertheless, considerable damage was still inflicted on many of the county's urban areas. In late 1941, West Bromwich, which was a centre of engineering and manufacturing, became a target for German bombs and fifty-eight people were killed in raids, mostly centred on the Oak Road and Lombard Street areas, just to the west of the town centre. Wolverhampton's Rubery Owen engineering factory (which made Brodie helmets and landing gear for military aircraft) was also targeted by German aircraft, and during these particular attacks nearby housing estates were hit, killing eleven people. Stoke-on-Trent was bombed on at least twenty

occasions during the Second World War, with the British Aluminium Works, Shelton Bar Steel Works, the Michelin Tyre Factory, and Stoke railway station being the particular focus of German attentions. The huge English Electric factory, on Lichfield Road in Stafford, was also attacked by German bombers in 1941. Approximately 10,000 people were employed at the factory, which produced tank parts, communication cables and other vital war materiel. The factory was certainly known to the Germans, as prior to 1914, the business had been owned by the Siemen brothers from Hanover. The factory was then taken over by the British government as a consequence of the 1914 Enemy Aliens Act, and it subsequently produced goods which were vital to the British war effort during two world wars.

Faulty detonators, combined with some inaccurate bombing, meant that the Germans were never able to seriously impede munitions production at the Stafford English Electric factory. Other, even more vital centres of war munitions production in Staffordshire were never touched at all by German bombs. The Royal Ordnance Factory at Swynnerton, near Stafford, was one of Staffordshire's greatest contributions to the British war effort during the Second World War. During the war roughly 33,000 people (predominantly female) worked at the factory around the clock, producing bullets for Spitfires, black powder for maritime illuminations, bombs, and a whole variety of other vital battlefield necessities. Much of the factory was underground and some buildings were camouflaged by fake church steeples and other contrivances. As a result, the crucial factory escaped the attentions of German bombers entirely, and munitions production continued unhindered throughout the course of the war. The factory recruited young women from Stoke and Newcastle-under-Lyme, and from around the country. The so-called 'canary girls' whose faces and hair were turned yellow by constant contact with the chemical tetryl (used in the production of explosives) continued their work unabated, in what was a triumph both for women and for the overall Staffordshire war effort.

The Cromwell tank (produced at English Electric's Stafford plant). (Courtesy of Morio)

8. Modern Military Units

The RAF presence in Staffordshire continued long after the end of the Second World War. At RAF Lichfield, for example, No. 51 Maintenance Unit prepared aircraft for foreign and domestic civilian use, until they were disbanded in 1954, and their work was continued by No. 99 Maintenance Unit until the station was closed down in 1958. Aircraft maintenance work also continued at RAF Stafford until 2006. RAF Hednesford's Technical Training School admitted its last recruits in 1947, before becoming a demobilisation and transit camp. From 1950 onwards, Hednesford then became a major training centre for thousands of new RAF National Service recruits. Despite the carnage caused by the 1944 explosion at RAF Fauld, the RAF continued to use the site for munitions storage until 1966, when No. 21 Maintenance Unit was finally disbanded. Even after this date the Fauld site was still used for ammunition storage by the US army between 1967 and 1973. After 1945, the Staffordshire Yeomanry alternated between being an armoured formation and an infantry unit. In 1947, it became part of the Royal Armoured Corps, with an HQ at Stafford, and three squadrons (A, B and C) based at Walsall, Stoke-on-Trent and Burton-on-Trent. Twenty years later, in 1967, the Staffordshire Yeomanry became an infantry unit, with headquarters at Wolverhampton, and three squadrons – A to C – based at Wolverhampton, Stafford and Burton-on-Trent. Like other military formations across the country, the Staffordshire Yeomanry had to cope with a plethora of mergers and amalgamations. In 1971, it became part of the Mercian Yeomanry, with B Squadron being designated the Staffordshire Yeomanry Squadron. Later on, even squadrons were to be merged. In 1999, A and B squadrons were merged to form a new A (Staffordshire, Warwickshire and Worcestershire) Squadron, which became part of a new formation called the Royal Mercian and Lancastrian Yeomanry. In 2014, the Staffordshire, Warwickshire and Worcestershire Squadron became part of the Royal Yeomanry Regiment, and during 2021 this squadron became simply the Warwickshire and Worcestershire Squadron, losing its Stafford lineage entirely. Despite this rather muted, inconspicuous end to well over 200 years of rich and varied history, the military heritage of the Staffordshire Yeomanry remains a cherished one, assessed in books and articles, and promoted in impeccable fashion by the Museum of the Staffordshire Yeomanry at the Ancient High House in Greengate Street, Stafford.

Staffordshire Yeomanry Museum. (Courtesy of Stocksy)

The new Staffordshire Regiment, created in 1959, lasted for forty-eight years, until it was amalgamated with the Cheshire Regiment and the Worcestershire & Sherwood Foresters in order to form the Mercian Regiment in 2007. The Staffordshire Regiment's time as a distinct entity was certainly quite limited, but it still contributed much to the overall military heritage of the county. It underwent five tours of Northern Ireland during the period of the Troubles, including one tour in 1972 when violence and terror was at its absolute height. In 1990, the regiment formed part of the legendary 7th Armoured Brigade – the so-called Desert Rats of Second World War fame – which was sent to Saudi Arabia when Iraq invaded Kuwait. The brigade was then used as part of the US General 'Stormin' Norman' Schwarzkopf's Desert Storm force, which rapidly pushed the Iraqis out of Kuwait.

The future demise of the Staffordshire Regiment was made known, publicly, in 2004. Even so, the regiment continued to serve with distinction during the Iraq War, between 2005 and 2007. In late 2006, the regiment's 1st Battalion led a successful raid on the Al Jamiat police station in Basra, southern Iraq, where Shia militia men were detaining and torturing hundreds of prisoners. About 127 prisoners were freed by the Staffordshire men and seven Shia gunmen were killed in the battle for the police building. The Iraq War was undoubtedly controversial in a political sense, but the Staffordshire Regiment conducted its military role in the conflict with all the professional skill and daring that one would expect from soldiers linked to a county with such a long and illustrious military tradition.

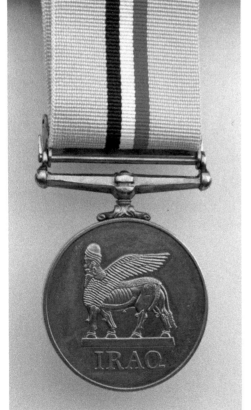

Above: Norman Schwarzkopf.
(© DoD File Photo)

Left: British Iraq War service medal.
(© Steve Dock LBIPP)

The Mercian Regiment was also deployed to Iraq, and, in addition, it undertook repeated tours of Afghanistan. In 2012, the Mercian 3rd Battalion, the principal successor to the Staffordshire Regiment, was disbanded. In order to maintain the connection with the county of Staffordshire, the regiment was renamed (in July 2014) and given the rather unwieldy title of the Mercian Regiment (Cheshire, Worcesters and Foresters and Staffords). More significantly, perhaps, the Mercian Regimental Headquarters remains at Whittington in Lichfield, retaining a link between the town and the county's various military formations that has lasted for more than 300 years.

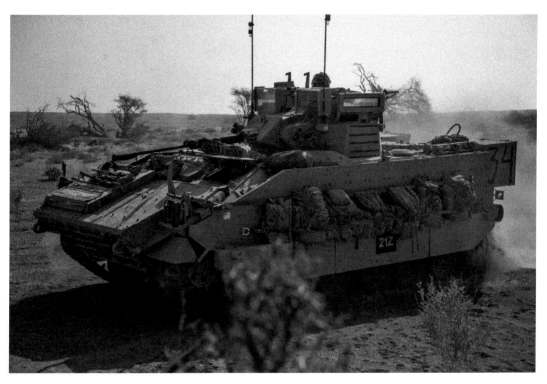

Mercian Regiment in the Oman desert, 2018. (© MODUK)

Bibliography

Ashdown, K., 'Swynnerton Roses Return to Workplace as Honoured Guests' (stokesentinel.co.uk, 30.12.2017)

Bishop, P., *Bomber Boys: Fighting Back 1940–1945* (Harper Press, 2007)

Bishop, P., *Fighter Boys: Saving Britain 1940* (Harper Perennial, 2004)

britishnewspaperarchive.co.uk

David, S., *Victoria's Wars: The Rise of Empire* (Penguin, 2006)

Deighton, L., *Fighter: The True Story of the Battle of Britain* (Grafton Books, 1990)

Hales, M., *Civilian Soldiers in Staffordshire 1793–1823* (SHURA, 1995)

Holmes, Richard, *Redcoat: The British Soldier in the Age of Horse and Musket* (Harper Collins, 2001)

Hunt, K., *Staffordshire's War: Voices of the First World War* (Amberley, 2017)

Lacey, R. and D. Danziger, *The Year 1000* (Little Brown UK, 1999)

Missen, L., *The History of the 7th Service Battalion, North Staffordshire Regiment 1914–19* (Cambridge, 1920)

Montgomery, B. L., *A Concise History of Warfare* (Collins, 1972)

Plant, D., bcw-project.org (2001–15)

Seward, D., *The Wars of the Roses and the Lives of Five Men and Women in the Fifteenth Century* (Constable, 2002)

Acknowledgements

The authors would like to thank Les Martin Militaria and numerous other libraries, archives and museums around the world for allowing them access to a wide array of military-related photographs and artefacts. Thanks are also due to the many private photographers whose publicly available images have been of considerable use in the production of this book. Every effort has been made to fulfil requirements with regard to copyright matters. The authors and publisher will be glad to rectify any omissions at the earliest opportunity.

About the Authors

Both Adrian and Dawn Bridge have been engaged in teaching, writing and talking about history for many years. Dawn, originally from Stoke, is a specialist in women's history, and Adrian has taught history at various FE and HE institutions across the country since the 1980s. Adrian and Dawn also come from families with strong military roots and traditions. As a result, the writing of this book has proved to be a particularly enjoyable experience for both writers.

Also by the Same Authors

A–Z of Northwich & Around: People, Places, History (Amberley Publishing, 2019)
Northwich & Around in 50 Buildings (Amberley Publishing, 2021)
Chester's Military Heritage (Amberley Publishing, 2021)
Secret Northwich & Around (Amberley Publishing, 2022)